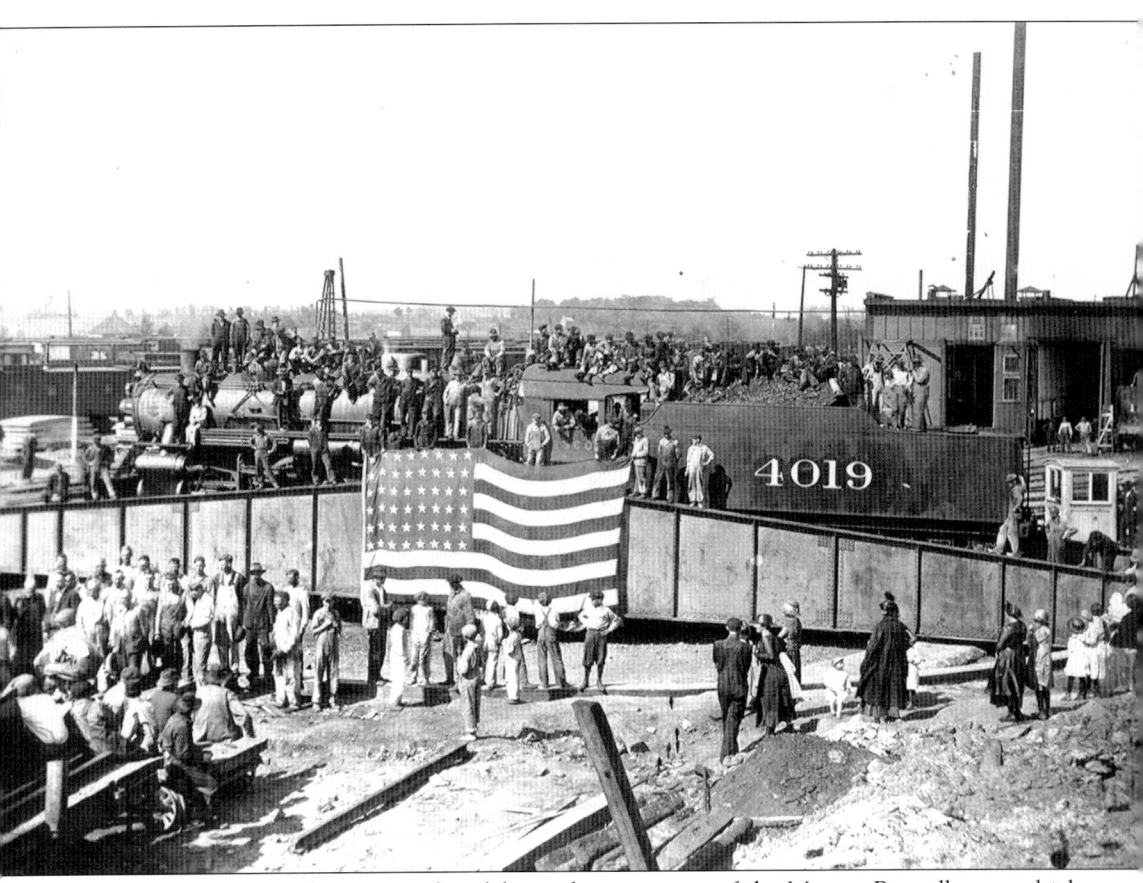

Frisco employees and townspeople celebrate the reopening of the Monett Roundhouse, which was burned on March 7, 1923, during the Great Railroad Strike. Nearly $1 million in equipment and engines was lost that day, and almost 150 employees were either out of work or had to relocate for a time. People were glad to be back on the job. (Courtesy of the *Monett Times*.)

*On the cover*: The Frisco Railway sponsored a beauty pageant, which was open only to family members of Frisco employees. This one, in the late 1940s, featured relatively recent Monett High School graduates Peggy Dawn Ellis (left), Wilma Ruth Rittenhouse (wearing the queen's crown), and Delores Huffmaster. The parade was part of a Fourth of July celebration. (Courtesy of the collection of Rod Anderson; photograph by Ed Shideler.)

Elaine L. Orr

Copyright © 2006 by Elaine L. Orr
ISBN 0-7385-4067-6

Published by Arcadia Publishing
Charleston SC, Chicago IL, Portsmouth NH, San Francisco CA

Printed in the United States of America

Library of Congress Catalog Card Number: 2006922108

For all general information contact Arcadia Publishing at:
Telephone 843-853-2070
Fax 843-853-0044
E-mail sales@arcadiapublishing.com
For customer service and orders:
Toll-Free 1-888-313-2665

Visit us on the Internet at http://www.arcadiapublishing.com

*This book is dedicated to the generous people of Monett, who value their history enough to celebrate it, and to my friend Leigh Michaels, writing teacher extraordinaire.*

# Contents

| | | |
|---|---|---|
| Acknowledgments | | 6 |
| Introduction | | 7 |
| 1. | Starting with the Frisco | 9 |
| 2. | Growing the Town | 19 |
| 3. | A Few People Make a Difference | 39 |
| 4. | Climate of Extremes | 47 |
| 5. | At Heart a Rural Community | 53 |
| 6. | Civic and Government Life | 59 |
| 7. | Schools and Sports Intertwined | 69 |
| 8. | Early Health Care Kept Expanding | 85 |
| 9. | Town of Many Churches | 93 |
| 10. | Enjoying Life and Celebrating History | 103 |
| Bibliography | | 127 |

# Acknowledgments

Not a Monett native, I relied on many individuals to find local photographs. Special thanks to Murray Bishoff, managing editor of the *Monett Times*, for his advice on sources and local history, and to editor and publisher Mike Stubbs, for permission to scan many historic photographs. Rod Anderson, a founder of the Monett Historical Society, has a large collection of local history items. He and his wife, Janice, let me scan photographs in their kitchen for an entire day. Betty Steele is an avid historian, and her late next-door neighbor Ed Shideler trusted to her some of the most important photographs that he took as one of the town's first and longest photographers. Betty and her husband, George, welcomed me to their home often and researched the cover photograph.

Mark Henderson learned of this project through his employer, EFCO, which circulated my request for photographs. He permitted me to scan many of his postcards and guided me to other sources.

Sinclair and Jane Rogers prepared a slide show for Monett's 1987 centennial. They gave me a personal presentation, which was the best history lesson a person could receive. Staff in the Monett Branch of the Barry-Lawrence County Library hosted me and my scanner on many occasions and guided me to books or historical articles. Especially helpful were Betty Alyea, Cindy Frazier, Joyce Reed (who also provided pictures), Lee Ann Rosewicz, and Jaime Rutherford.

I never learned the name of "Meteor Man," whom I met online, but I am very grateful for the many Frisco photographs and articles he mailed me. Keith Owens and Robert Banks Jr. were also online sources. Bob (who maintains the Jeffries Collection) has collected and published online many old newspaper articles on Monett. They were invaluable. Amy Barker, high school yearbook advisor, found students to take some present-day photographs, and Dick Huennekens and Wayne Rutherford let me have my pick of photographs from the American Legion Hall.

My husband, Jim Larkin, supported my absorption in this project and his mother, Lois, fed our cats when I went to Monett when Jim was also away—despite being allergic to them. Thanks also to cousins Doug and Harriett Seneker of Mount Vernon, Missouri, who hosted me when I traveled to Monett.

# INTRODUCTION

The predecessor to Monett was a small town called Plymouth Junction, which boasted a depot and telegraph and had a few businesses and residents. When Plymouth Junction burned on September 8, 1886, $2,800 of the estimated $5,000 in lost property belonged to one man, M. J. Jeffries, who was the town's first doctor and owned the drug and grocery store and small hotel. On May 5, 1887, Pierce City, Missouri, newspapers reported that the St. Louis and San Francisco Railway (the Frisco) had changed the name of its Plymouth station to Monett and would begin to build a roundhouse, where trains could be serviced. The town was named for Henry Monett, who was a passenger agent for the New York Central and Hudson River Railroad.

Despite the rancor citizens of Pierce City felt when the railway left (believing it to be because the Frisco was unhappy over some business dealings with local townspeople), the relocation of the Southwest Missouri Frisco Division was a matter of topography. It was all about who could build railroad service to Texas, and the grade was better going out of Monett.

Monett's citizens built a thriving health care system, hosted rumrunners during Prohibition, sent their citizens off to wars, and educated their children. The many churches throughout town reflect a community of deep faiths. Although built because of the Frisco, the heart of its economy is agriculture and dairy farming. Today it boasts large meat and dairy processing plants, and there are still wholesale fruit and vegetable dealers.

Beyond industries that have grown from its traditional bases, Monett has many that could be housed anywhere—such as EFCO's large window factory and Jack Henry and Associates software firm—but prefer the environment and the people of Monett. The workforce has always been a well-educated one, but the faces of the people who comprise it are more diverse today. Many Central American immigrant families have joined the traditional Irish and German population. Without their labor, some employers would undoubtedly have to move elsewhere.

Monett is also a great place to have fun. There are high school and intramural sports, a golf course, ball fields and tennis courts, and a large municipal pool. The pool is within the City Park, a beautiful open space in the town itself. Within it is the Park Casino, not a site for gambling, but a building for civic events or hosted parties.

Music and arts abound, and the Monett Branch of the Barry-Lawrence County Library is a busy place. More so than other towns of its size, Monett has celebrated its local history. The 50th and 100th anniversary celebrations also included extensive historical articles in the *Monett Times* and special publications. A core group of local historians formed the Monett Historical Society, although it struggles with the need for a place to exhibit its collection and provide access for researchers. Perhaps this book will be a catalyst to garner the interest to achieve that. Most of all, Monett is a great place to live. People are friendly and helpful, and the schools are modern. The residents today will be part of the history recorded tomorrow.

# One

# STARTING WITH THE FRISCO

When the St. Louis and San Francisco Railroad (known as the Frisco) laid tracks at Plymouth Junction in 1880, it created the forerunner of present-day Monett. Plymouth Junction (whose post office was called Gonten) was about five miles east of Pierce City, Missouri, which was an important shipping point for Southwest Missouri and Northwest Arkansas and home to the Southwest Missouri Frisco Division. The heaviest grade on the railroad between Springfield, Missouri, (44 miles to the Northeast of then-Plymouth Junction) and Wichita, Kansas, was just outside of Pierce City. Plymouth Junction offered flatter terrain to link into the Frisco's new line that was to run to Fayetteville and Fort Smith, Arkansas, and then on to Texas.

The Frisco moved its division point from Pierce City to Monett in September 1887, which meant trains would stop there for meals and passenger overnights, service to engines and cars, and to change crews. This left angry citizens of Pierce City to accuse railroad officials of profiting from the sale of land in the new Monett and predicting that businesses that settled in Monett would soon leave it for the brick homes and conveniences of Pierce City. That prediction proved false. The Frisco's switch to Monett brought about 300 jobs overnight.

Monett's identity and economy were closely tied to the Frisco for almost 70 years. The railway was more than an employer, it was a culture—for better or for worse—that affected the families of its employees, the school system, and other businesses. It was largely a generous entity, although it used its influence to try to sway behavior or business. Today memories of the Frisco are largely positive, and people speak fondly of the times that passenger trains shared the rails with today's freight trains.

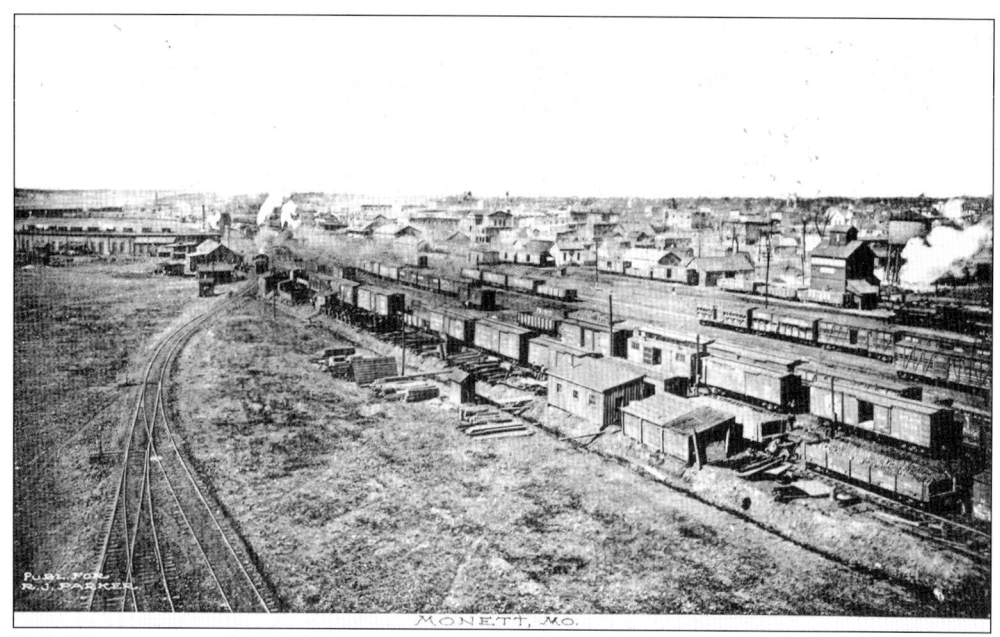
Early Monett grew to the north and was initially made up of frame buildings, and then later comprised a mix of frame and brick. On the left, in the back, is the first roundhouse, which was the building in which railcars and engines were serviced. (Courtesy of the collection of Rod Anderson.)

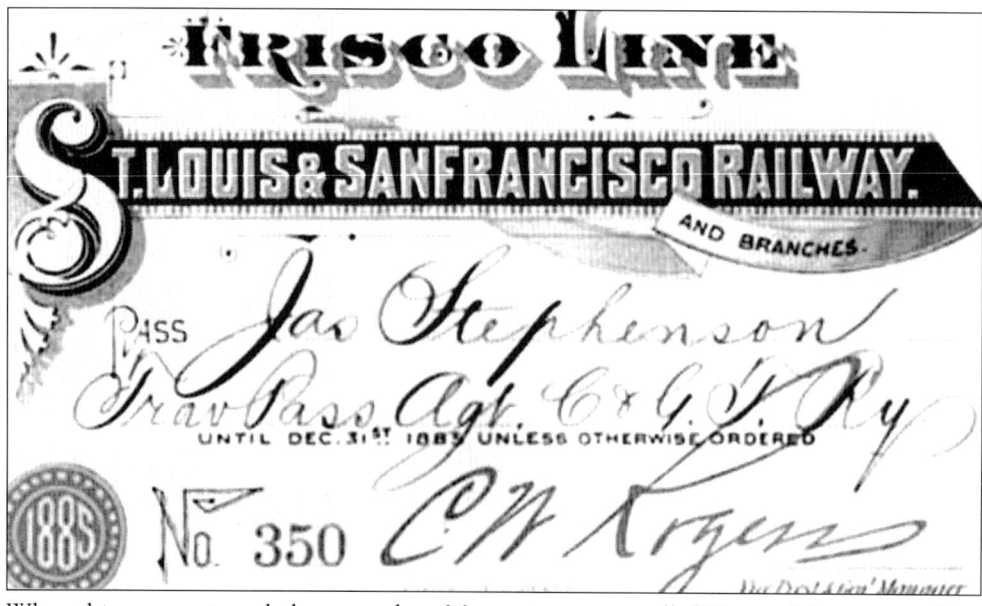
When this pass was issued, the town where Monett is now was called Plymouth Junction and few trains stopped there. While most travelers had tickets for a specific trip, Frisco employees and their immediate families received passes for free travel. (Courtesy of the *Monett Times*.)

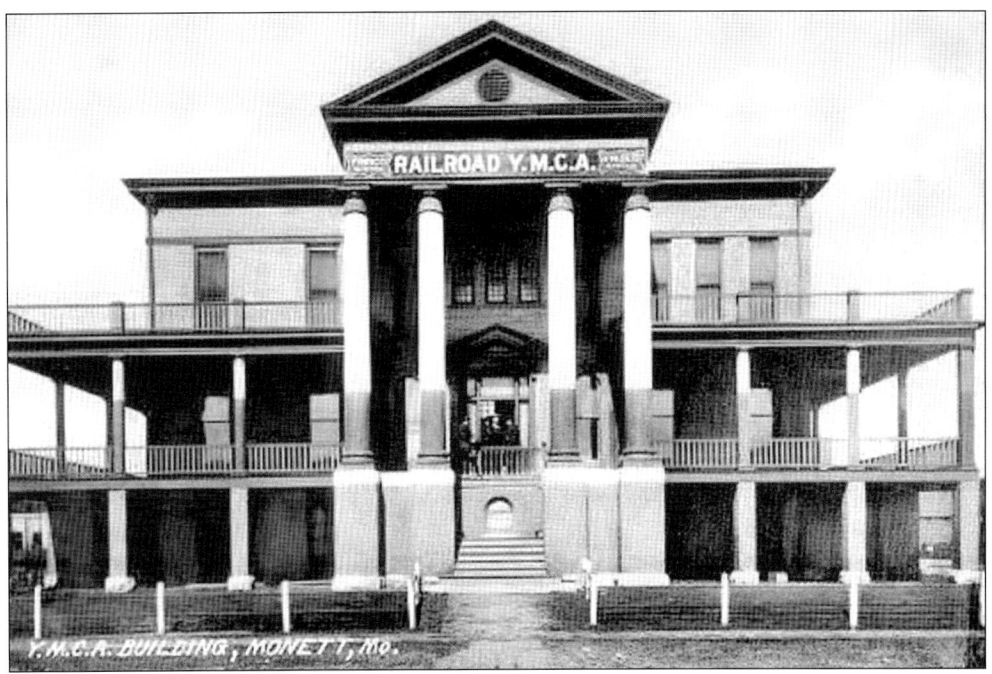

The Monett YMCA was part of that organization's efforts to erect facilities along major rail lines and was the first on the Frisco line. It was designed by Theodore C. Link of St. Louis, opened December 26, 1899, and cost $9,500. It stood on Front Street, near the depot. Prominent Monett businessmen were among its first directors, including E. Akers (president), H. Ward Day (vice president), and H. I. Bradford (secretary). (Courtesy of the Frisco Meteor Man.)

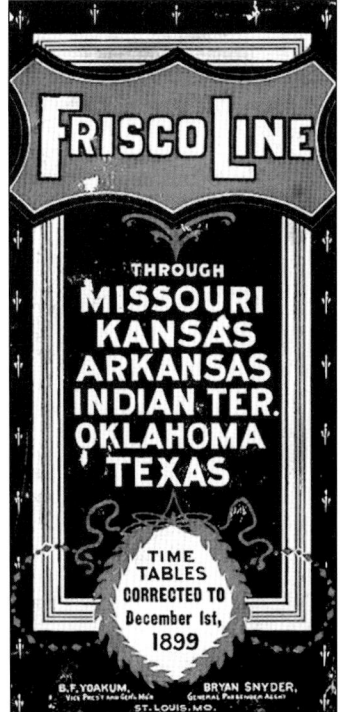

Timetables were essential given that few had access to a telephone and travelers might have to switch trains several times to get to their destination. This one says "timetable corrected" in prominent lettering so that travelers would know not to rely on a previous edition. (Courtesy of the Frisco Meteor Man.)

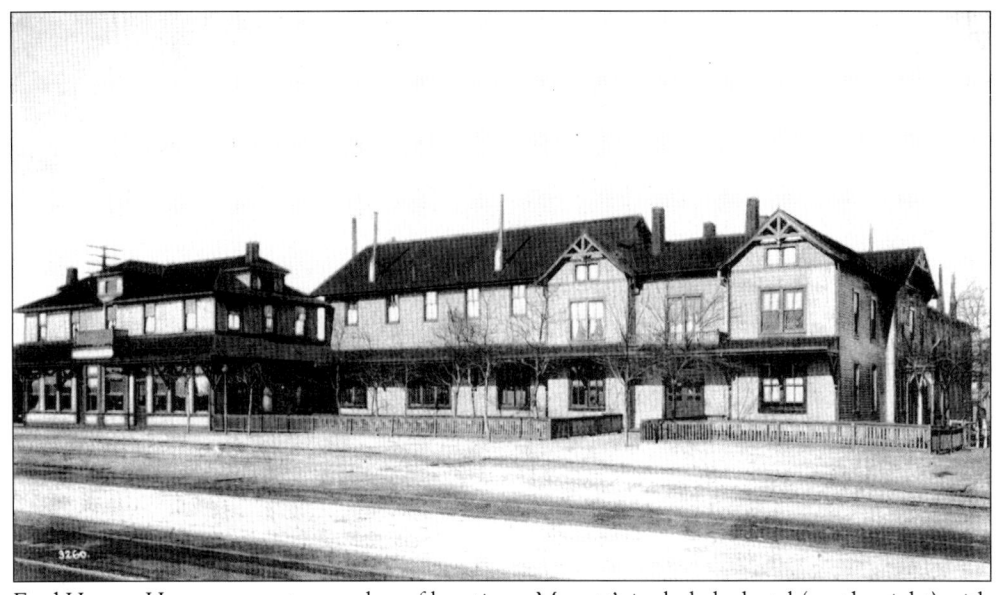

Fred Harvey Houses were at a number of locations. Monett's included a hotel (on the right) with 42 rooms and a dining room. The building on the left had a lunchroom that seated 40 and a newsstand that prided itself on carrying magazines and newspapers from many towns. They were delivered by rail, of course. (Courtesy of the collection of Rod Anderson.)

The Frisco emblem is the image of a coon skin that G. H. Nettleton, vice president, saw tacked to the side of the station in Neosho, Missouri. He asked the station agent why the skin was drying there and was told that it was hard to support a family on $1.25 per day so he tanned and sold hides. Nettleton bought the skin and had artists copy the shape and insert the word Frisco. (Courtesy of the Frisco Meteor Man.)

Railroads could not have shipped cold goods without the icehouses that stood along their routes. The Railway Ice Company at Monett was part of a chain of "ice factories" and produced 75 tons daily. Ice availability was important for shipping Monett's strawberries to market. The company also supplied the city with distilled water ice and operated the largest coal yard in the city.

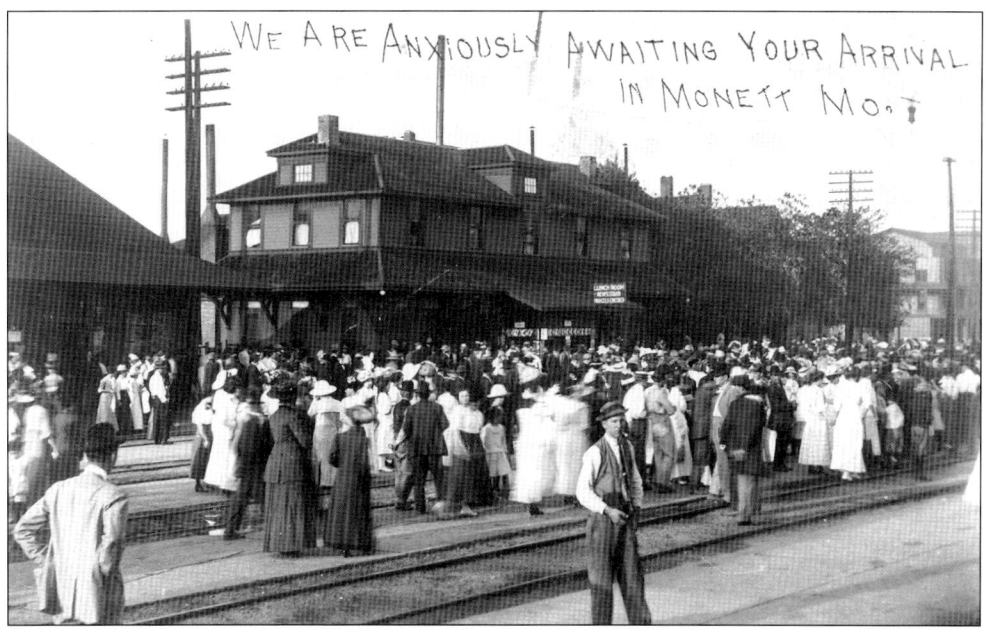

A train with an important visitor must have just pulled into the station, and the crowd was spreading across the tracks to hear a speech. To the left is the Harvey House. The sign above the newsstand, which was run by C. C. Gimble, lets passengers know they can check parcels there.

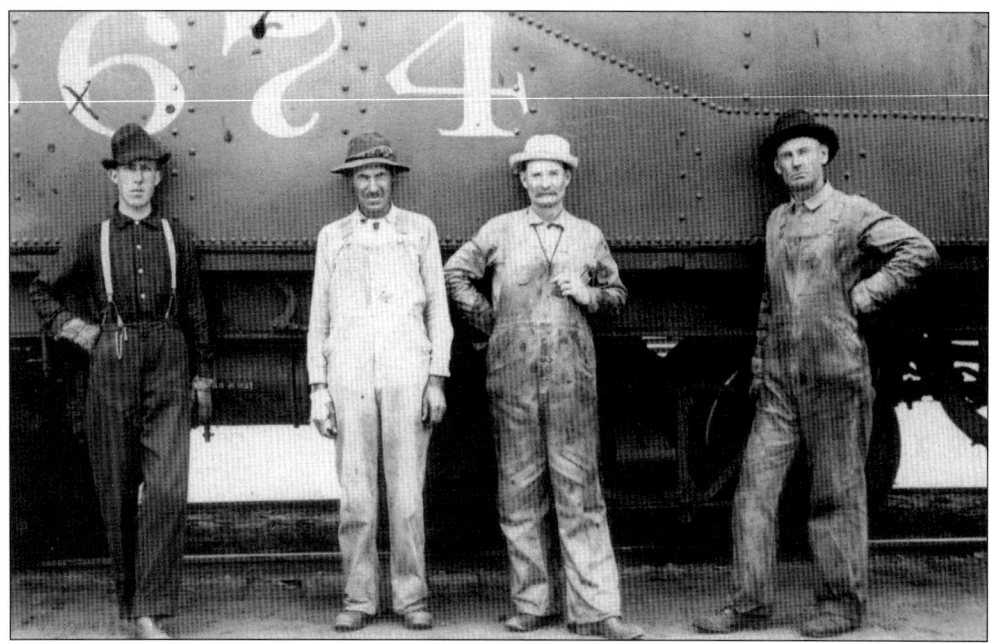

Earl Jeffries, son of Leroy and Mary, is at the left. The other three men are unidentified, although a note on the back says "compliments of Paddy Clinton 5/27/12." Earl Jeffries was a switchman. On the night of April 3, 1914, he fell beneath the moving cars of a train in the Monett yard and was killed instantly. (Courtesy of the Jeffries Collection.)

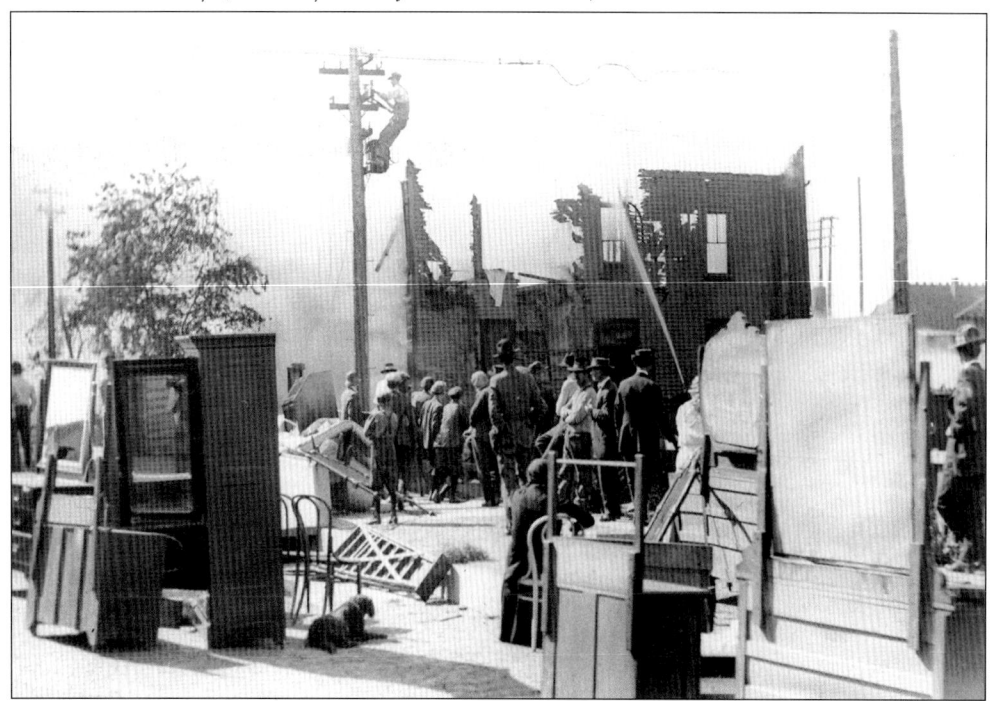

The elegant Harvey House burned in 1912. People tried to save what they could from the burning building. It was such a big event that schools were released so students could watch the fire. (Courtesy of the collection of Betty Steele; photograph by Ed Shideler.)

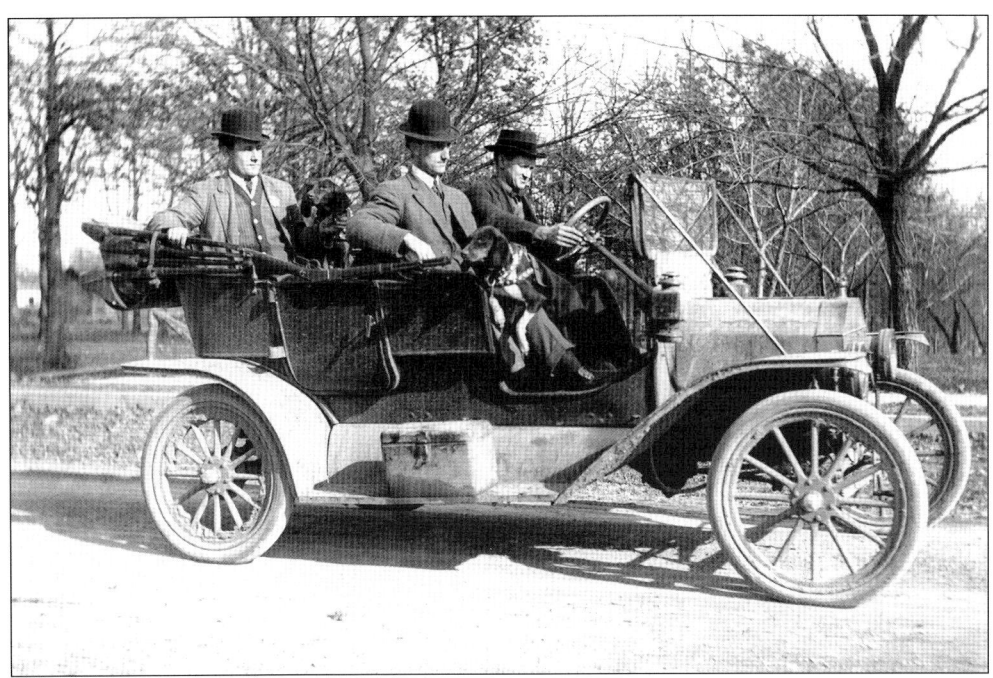

Frisco detectives investigated crime on the railways. They visited towns to conduct investigations or simply remind the public that they existed. Monett's railway security officer O. C. Medlin tried to keep people from jumping into freight cars to hitch a free ride. Young people who attempted joy rides to Pierce City were said to tell one another that it was "better to be dead" than caught by Medlin. (Courtesy of collection of Rod Anderson.)

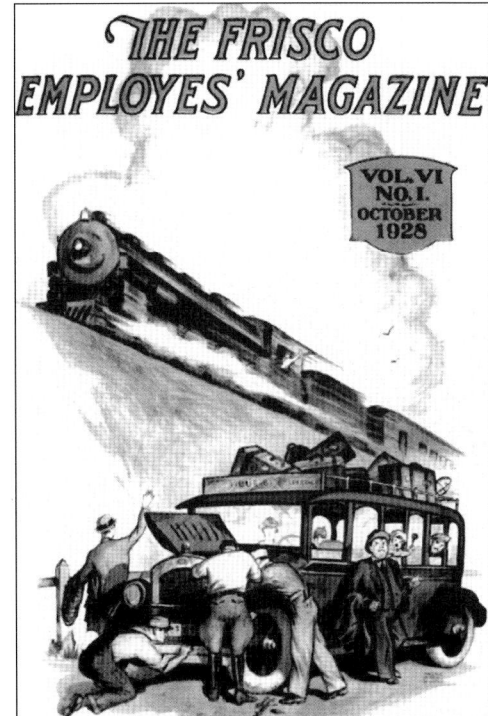

The *Frisco Employees Magazine* had short columns from all its major division cities. Sometimes it mentioned who was doing what within the Frisco, and other times it highlighted employees' participation in civic activities. The company also sponsored friendly competitions, such as best garden near the rails. (Courtesy of the Frisco Meteor Man.)

A roundhouse contains several stalls that hold locomotives and other railroad cars. As the name implies, it is constructed in an arc around a central turntable, basically a bridge that rotates from a center point. A car is pulled onto the turntable, which moves until the tracks line up with the intended stall. (Courtesy of the Frisco Meteor Man.)

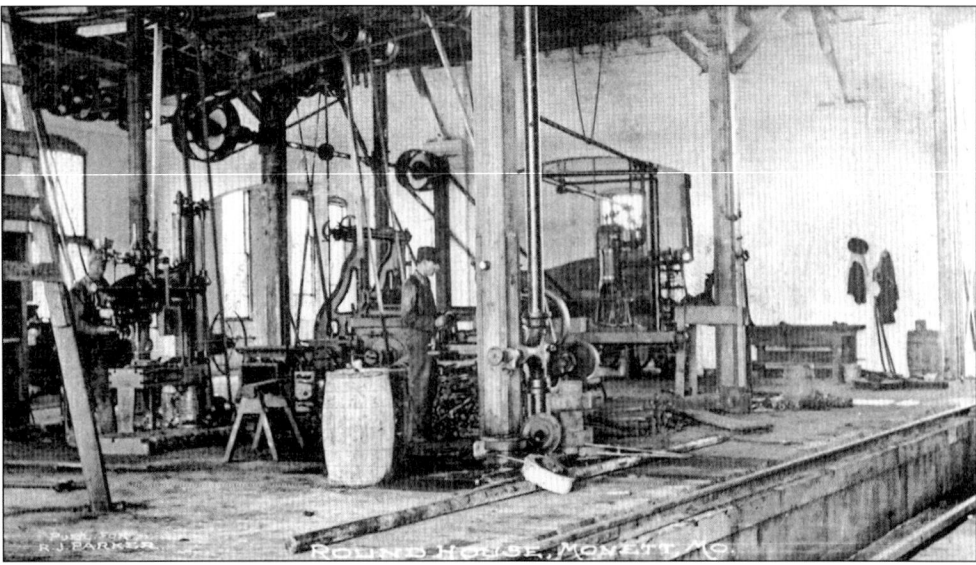

The interior of the roundhouse had strong pulleys so that cars could be raised for workers to get underneath for repairs. Working quarters were cramped, and in the summer, the heat could be substantial. The work was dirty, but the pay was higher than many other Frisco jobs. (Courtesy of the collection of Rod Anderson.)

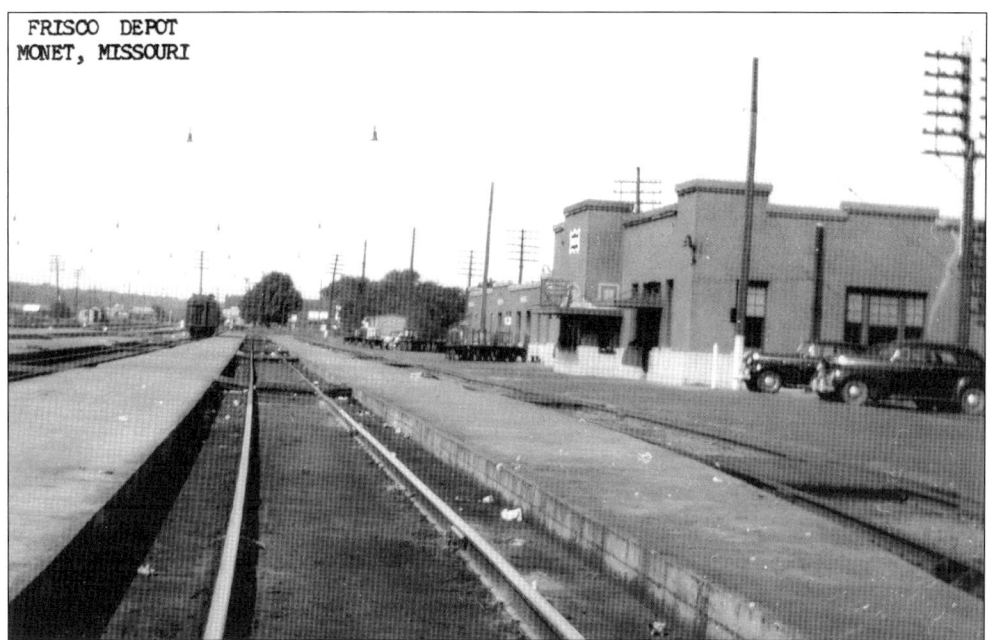

By the early 1930s, Monett's depot was a concrete structure. While not as attractive as the former depot, it was far more fireproof. The depot had a newsstand and seating area. Without the Harvey House, passengers had to walk a short way for meals and hotel accommodations. (Courtesy of the collection of Rod Anderson.)

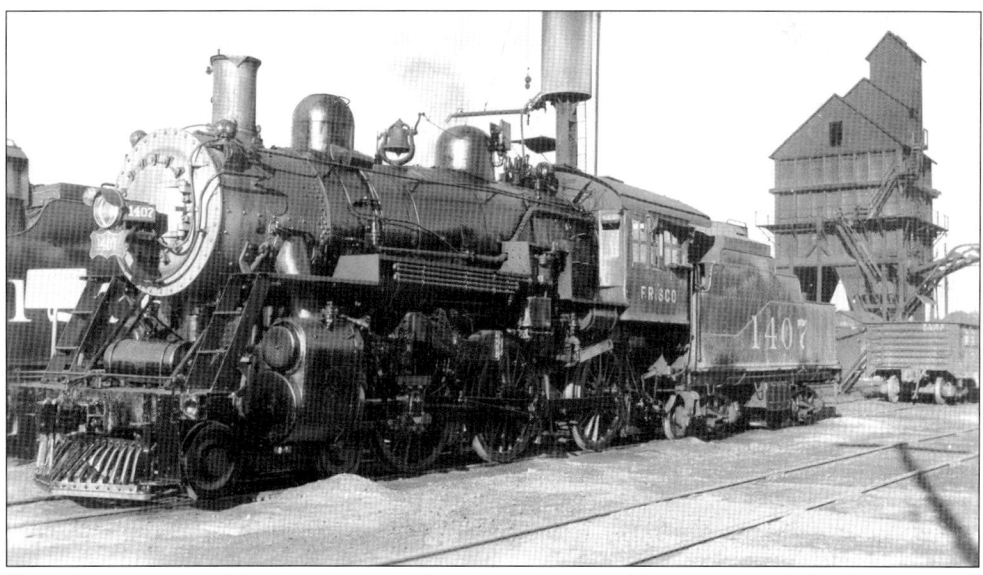

Frisco locomotive 1407 was a more modern steam engine. The structure behind it is a coal tower. The train would pull beneath it, and coal spilled down a chute into the waiting cars below. This Monett tower still stands, but it is now enclosed in concrete walls. (Courtesy of the Springfield-Greene County Library.)

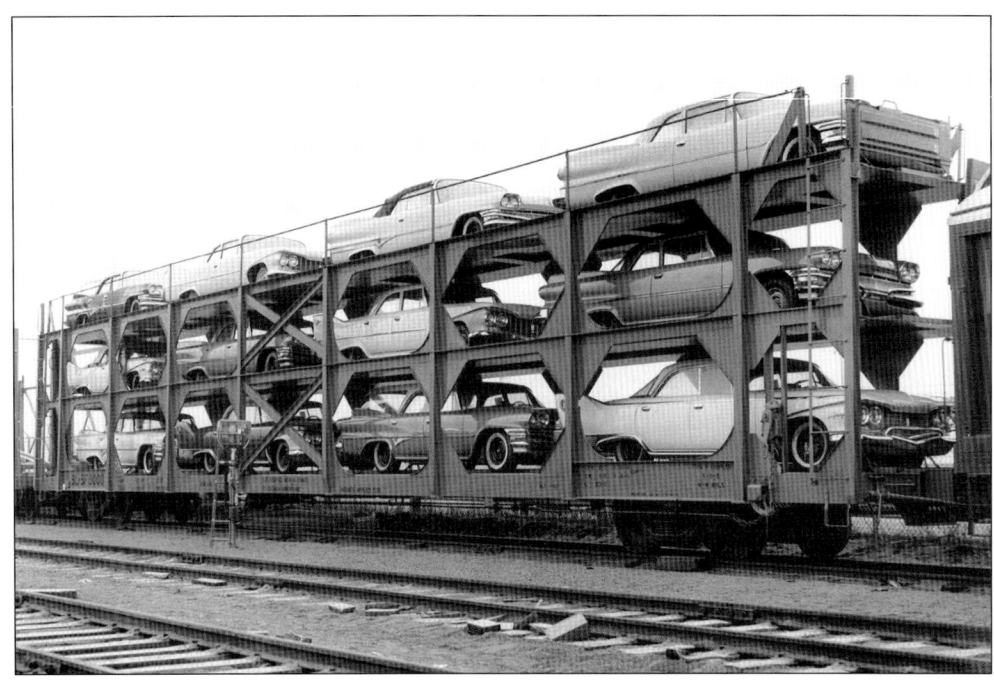

Automobiles of the 1950s were often seen going through Monett. Railroad man Arnold Eperly, nicknamed Ep, told high school student John Carey (who did a history paper on the Frisco in Monett) that an engine would pull about 30 flatbeds with automobiles, about twice the length of a normal train of those times. (Courtesy of the Springfield-Greene County Library.)

A view from the bridge over Kelly Creek shows the area that once housed the large frame depot of the early 20th century, Harvey House, and the YMCA. Closest to the tracks now are warehouses. (Photograph by Amy Newbold.)

18

# Two

# Growing the Town

Early views of Monett show a fairly compact town of frame buildings and houses that initially spreads north and west of the Frisco depot. Soon there were more brick buildings and a series of hotels along Broadway and in the blocks from Broadway to the rail station. Most industries supported the railway and the people who worked for it. The Frisco's presence allowed other businesses to flourish and drew shoppers from throughout Barry and Lawrence Counties. People would drive or come by train to shop.

Horses and buggies that traveled on dirt roads were replaced by automobiles and paved highways. Industry grew more diverse, and the town expanded from the area around Broadway and the railroad tracks, initially to the north.

Because of the foresight of those who formed the Monett Industrial Development Corporation (MIDC) after World War II, Monett did not have a major economic slump after the Frisco moved its division point in the mid-1950s. The MIDC anticipated that the growth in automobile and truck traffic would much reduce the use of railroads and its members were aggressive in bringing to town firms such as EFCO's window builders and the Vaisey-Bristol Shoe Company.

While there are still vibrant small businesses and restaurants downtown, there are also big box stores and chain restaurants, mostly to the south. While some resent their presence, most welcome them as services that have helped the city grow, albeit slowly, while some nearby towns have not.

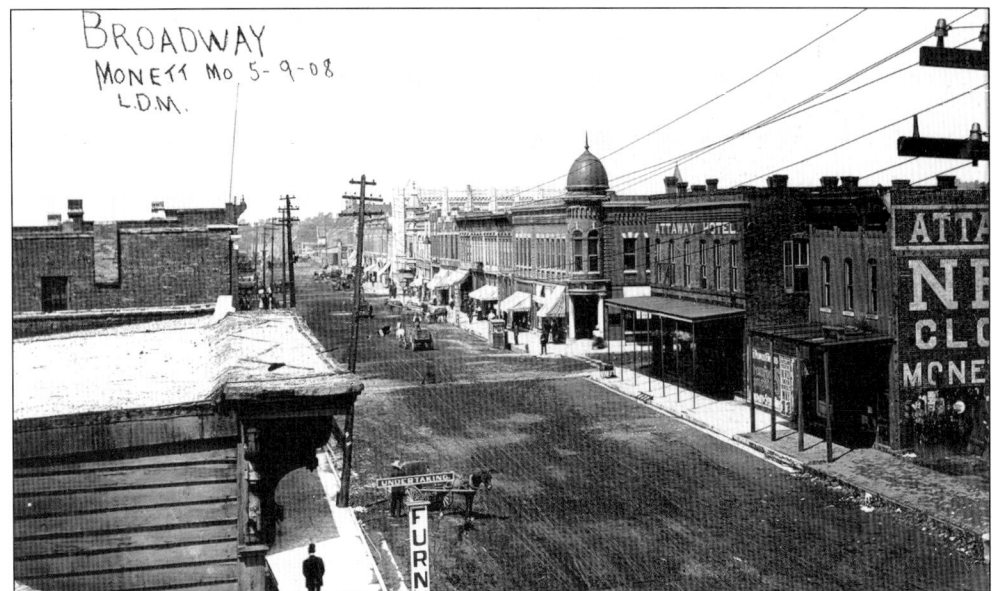

This 1908 view of Broadway looks west from Fifth Street. The Attaway Hotel and Monett State Bank, which has the dome, are on the right. The small buggy in the foreground is an undertaker's wagon. The Attaway was later the Broadway Hotel. In 1975, it became Gillioz Bank, and the building is now the United Missouri Bank. (Courtesy of the Monett Library collection; photograph by Logan D. McKee.)

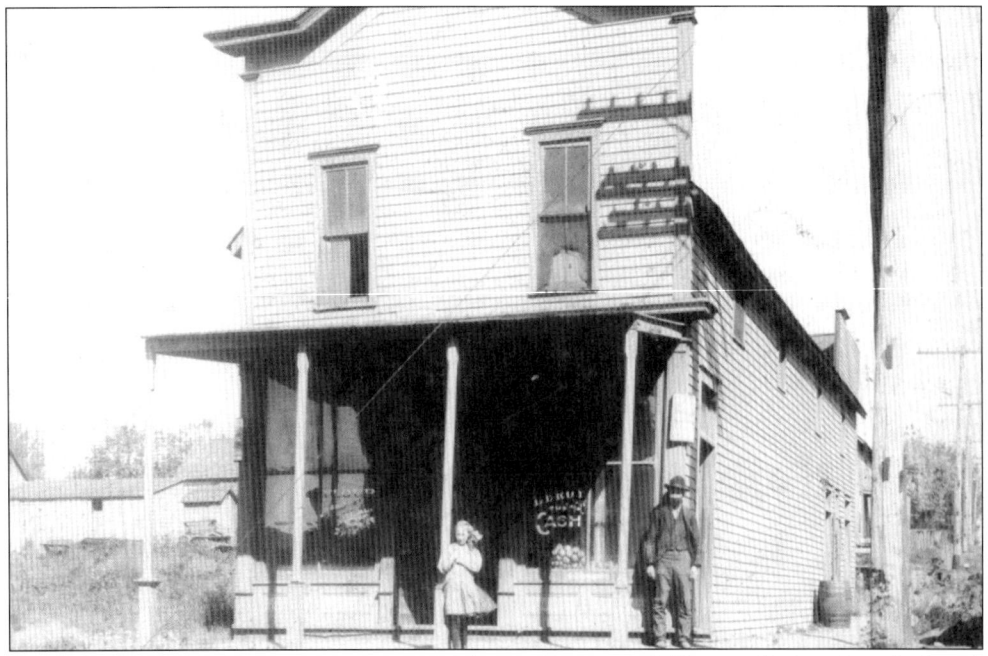

Leroy Jeffries (son of Monett pioneers Dr. Thomas Hampton Jeffries and Mary Jane Ricketts) and his daughter, Lalah (nicknamed Trink), stand in front of his third store in Monett. The Jeffries family arrived 1882, when the town was still Plymouth. Other than when he served as a county official and lived in Cassville (1914 to 1922), Leroy was a lifelong resident. (Courtesy of the Jeffries Collection.)

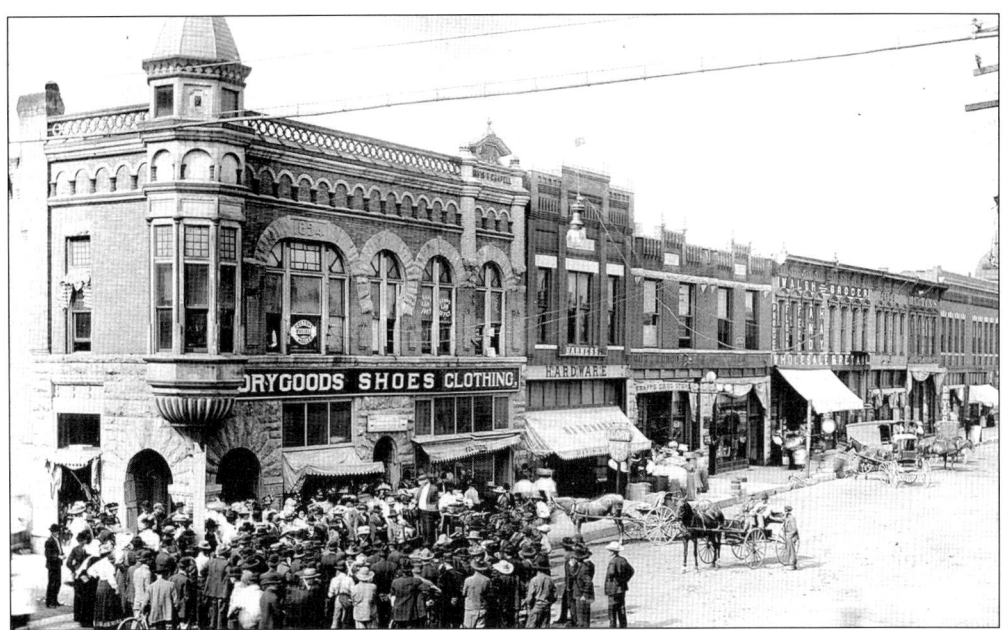

This view is of Broadway looking east from Fourth Street. The dry goods store on the left is actually the elegant Newman's Department Store. Looking closely shows that a man on a soapbox has the crowd's attention. (Courtesy of the Monett Library collection.)

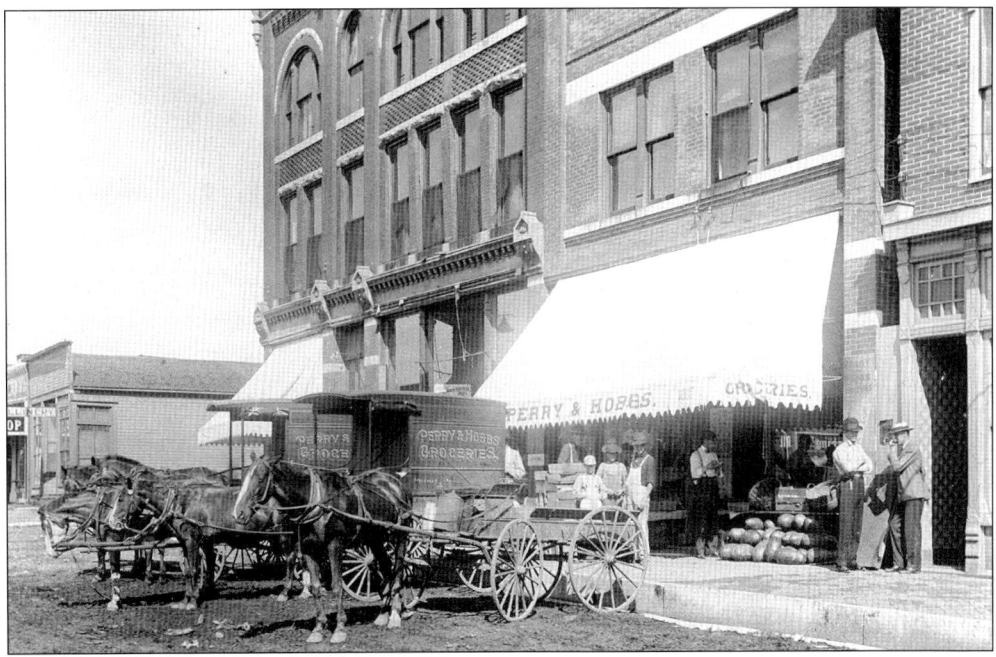

The Perry and Hobbes grocery was in a prominent location on Broadway. Note the watermelons stacked on the sidewalk. (From the Monett Library collection.)

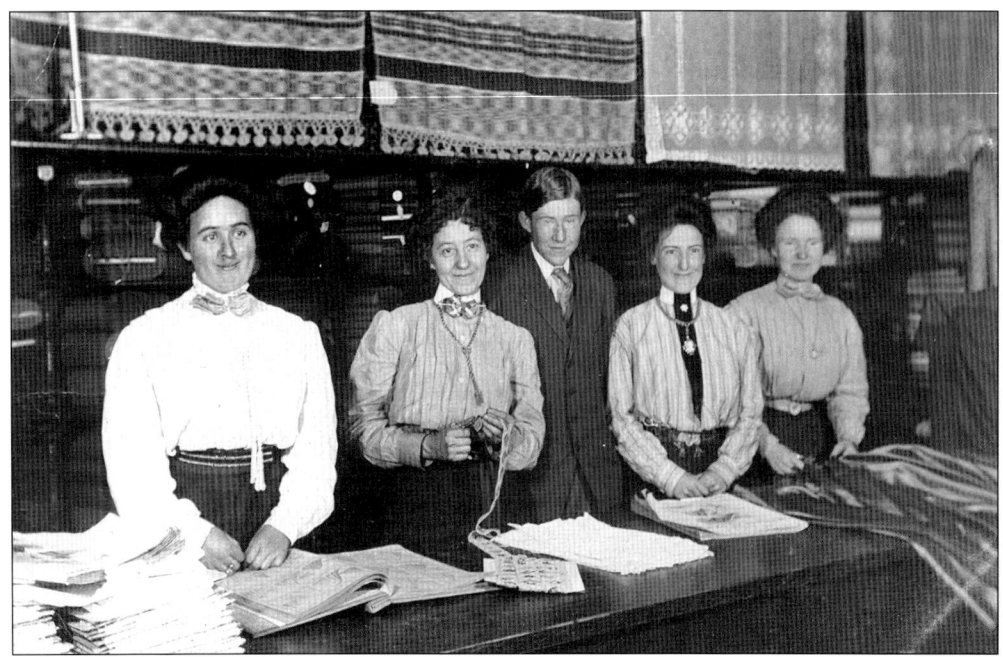

The bolts of fabric behind these five workers indicate that they work in a dry goods store, which often carried almost everything except food or heavy hardware. They later began to sell ready-to-wear clothes, as they were called, in addition to sewing fabric. From left to right are Nell Carey Tucker (Mrs. W. J.), two unidentified workers, Christine Johnson, and Anna Cunningham. (Courtesy of the Monett Library collection.)

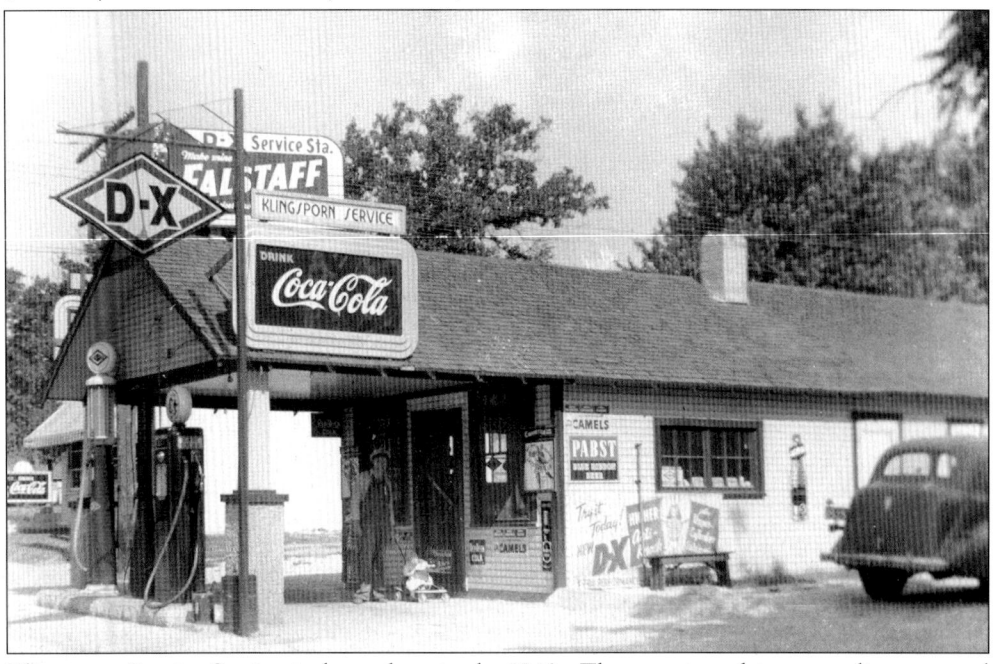

Klingsporn Service Station is shown here in the 1940s. The man is pushing a gasoline-powered lawnmower. The Klingsporn family had a small apartment behind the station. (Courtesy of the collection of Rod Anderson; photograph by Ed Shideler.)

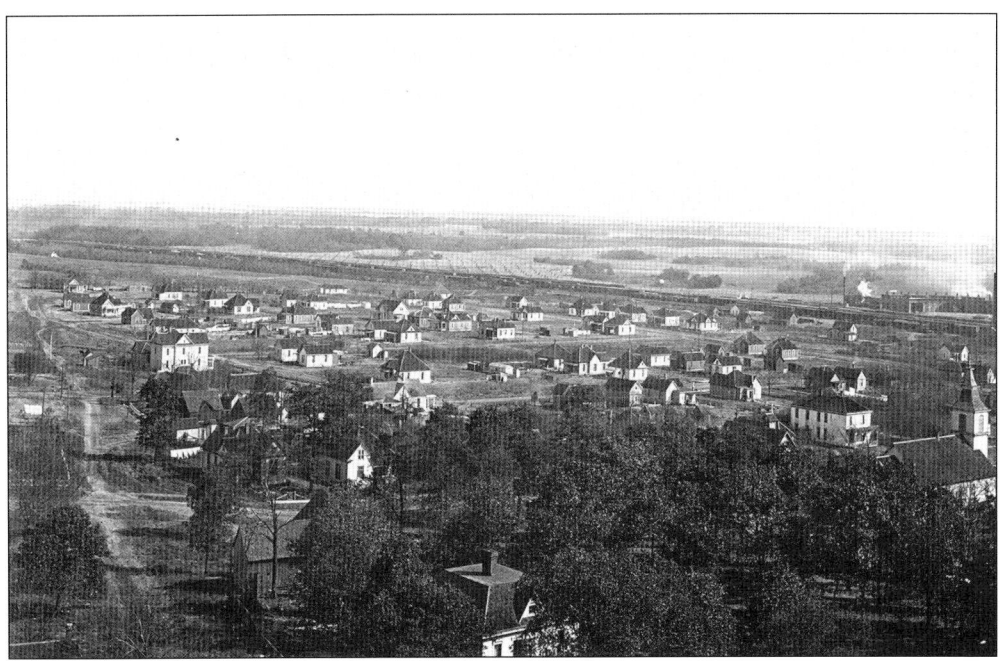

This aerial view looks east and shows how poor the roads still were 1909. The Frisco roundhouse is on the far right. Many of the houses have small outbuildings that would have housed chickens or the family cow. (Courtesy of the Monett Library collection.)

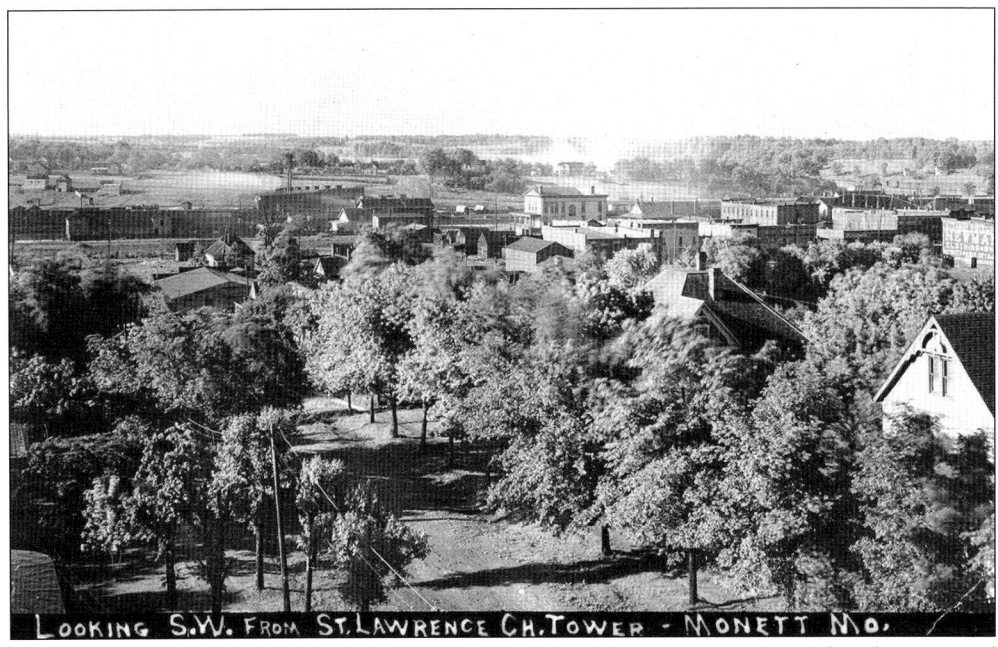

This aerial photograph looks southwest toward Broadway from St. Lawrence Church tower and was probably taken in 1909. The YMCA is the tall, light-colored building, and to the left of it is the Harvey House. (Courtesy of the Monett Library collection.)

These two girls standing by a downtown well are in their Sunday best, but their identities are unknown. While the railway and others dug wells even before the railway moved to Monett, water was not always an easy commodity until 1902. Prior to that, railcars sometimes backed into Pierce City to bring back carloads of water. (Courtesy of the collection of Betty Steele; photograph by Ed Shideler.)

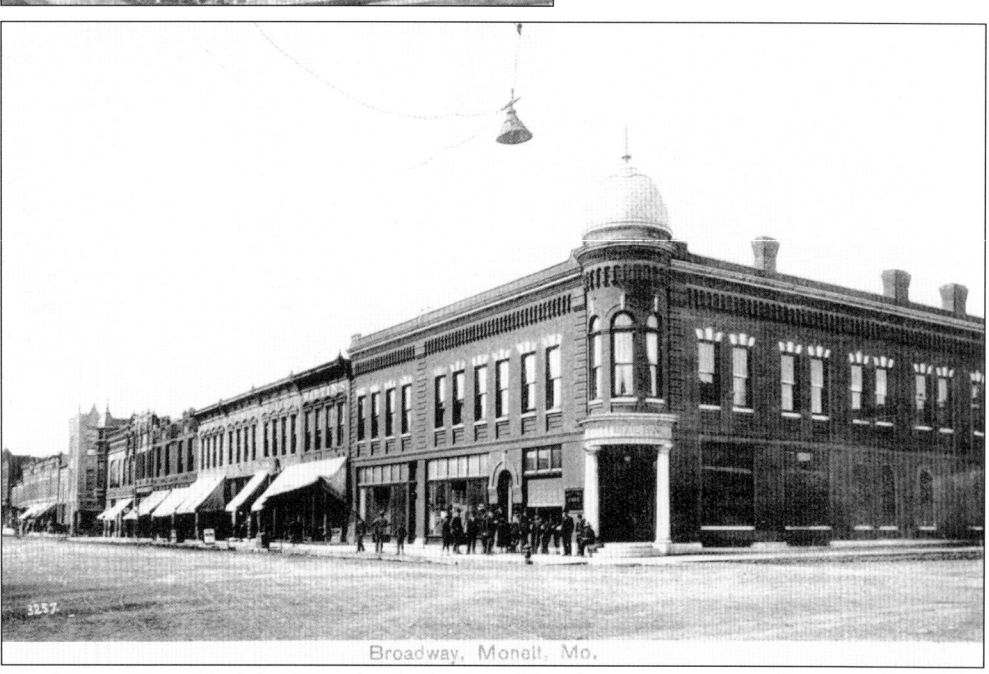

The Monett State Bank building (with the dome) has been a prominent fixture on Broadway since 1904. While it remains today, it is vacant and its deteriorating condition would indicate it may not last much longer. (Courtesy of the collection of Mark Henderson.)

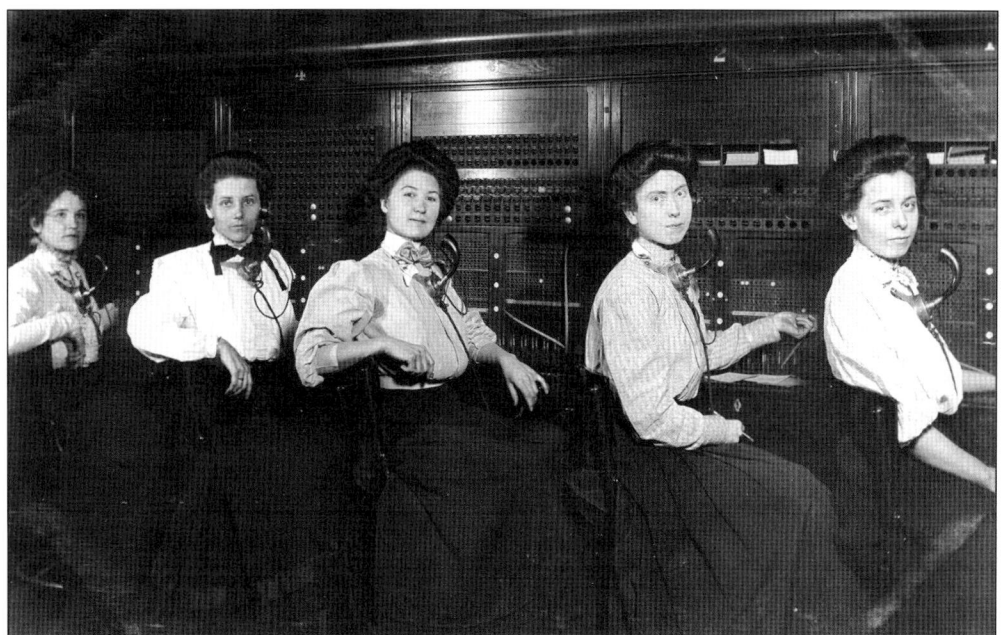

Monett's first telephone service began in 1895. Initially all calls were routed through a central switchboard. It was possible to tell when a business obtained a telephone by looking at its telephone number. The Owl Café had number one. (Courtesy of the Monett Library collection.)

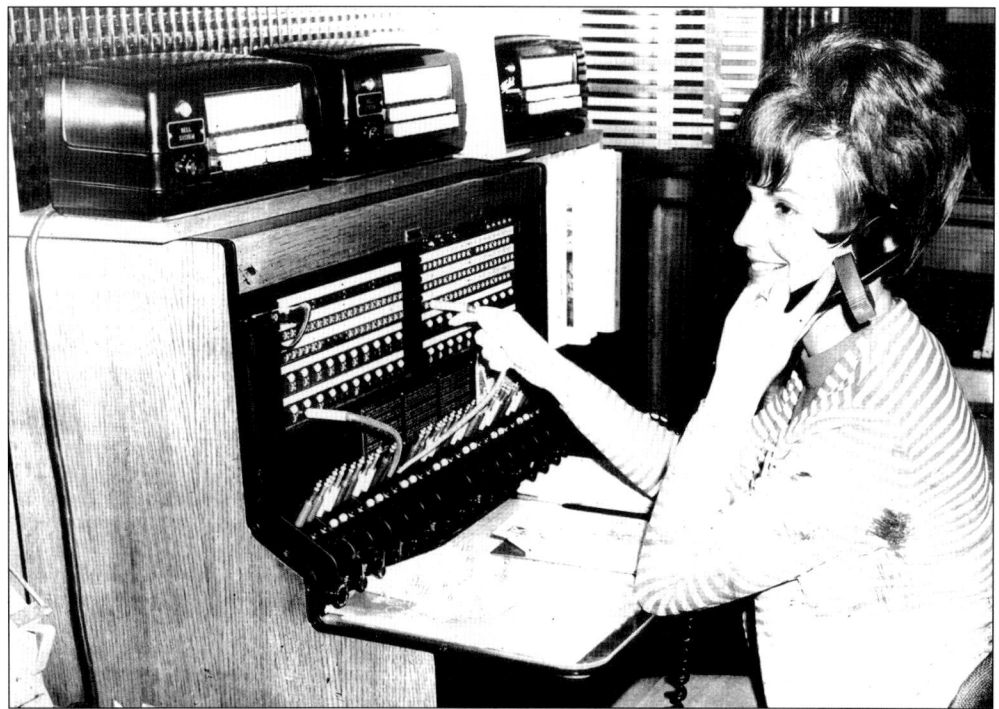

The company operator at Vaisey-Bristol Shoe Company had a newer switchboard in the early 1960s, but all calls for the company still came to her central location. (Courtesy of the *Monett Times*.)

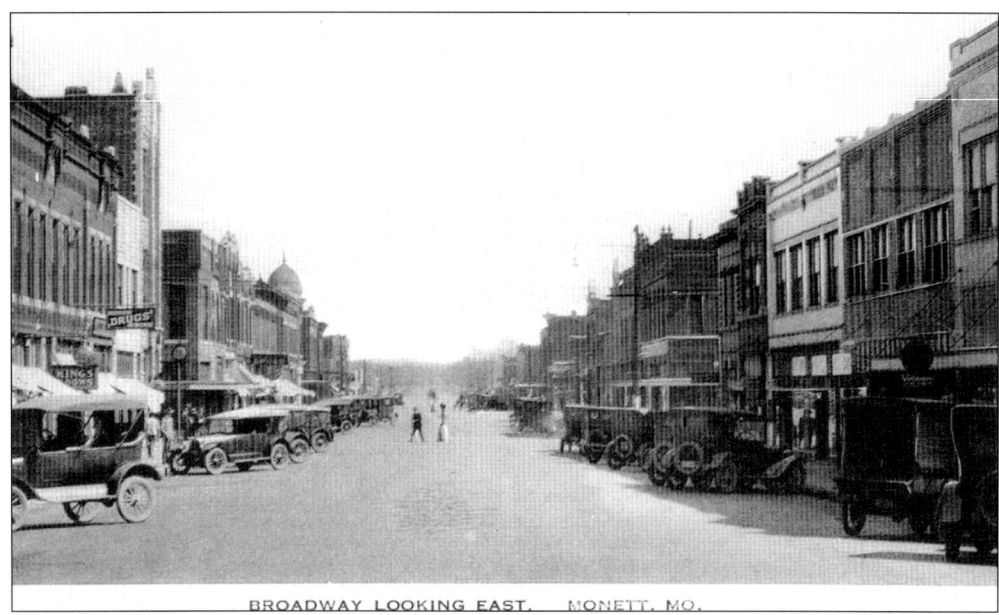

This view looks east on Broadway in the 1920s. There are a number of Monett citizens who maintain that the only way to tell when many photographs of Broadway have been taken is to look at the cars. (Courtesy of the collection of Rod Anderson.)

*Monett Times* paper boys read their product. It is in large part because of the newspaper's continuous publishing since 1899 that the town has such good records of its history. The paper boy on the left is noted to be Ralston Campbell. (Courtesy of the collection of Rod Anderson.)

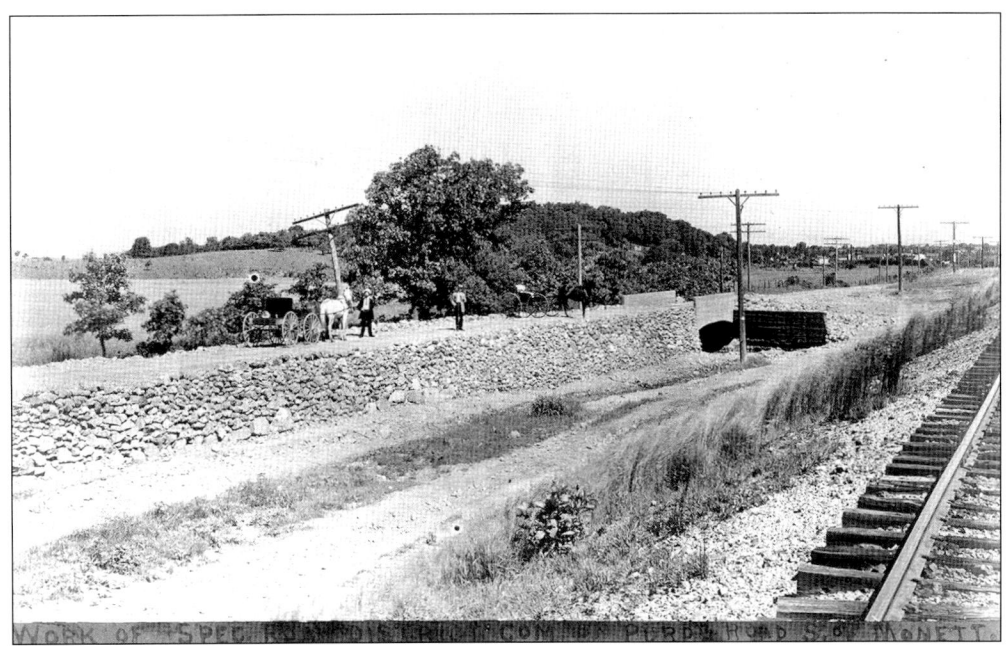

No one thought of travel as easy before roads were built where wagon tracks had once marked the routes between towns. This is the largely completed road that connected Monett to Purdy, Missouri, a few miles to the south. Paving came much later. (Courtesy of the Monett Library collection.)

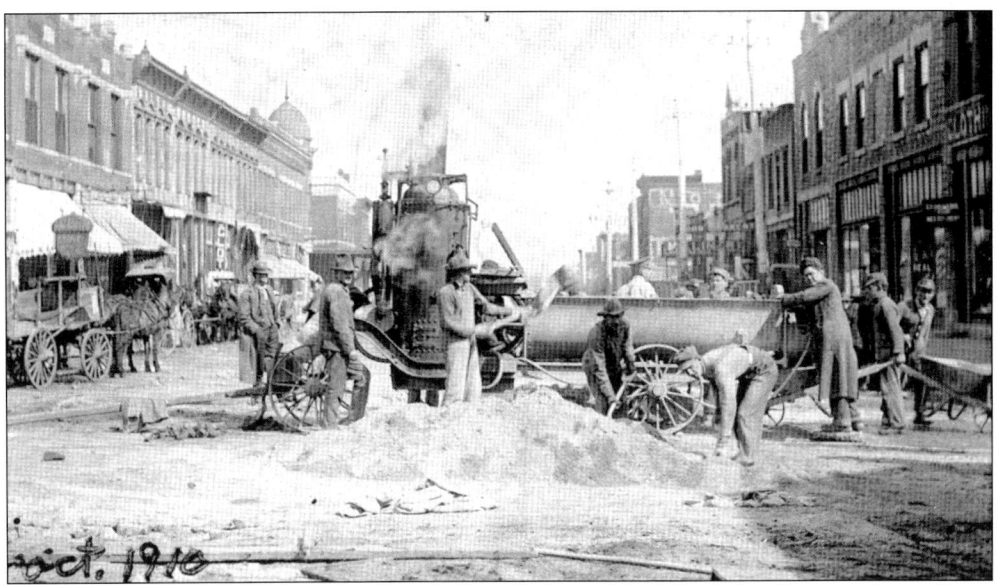

Monett's dirt streets were bricked beginning about 1916. Since there was not something akin to a large public works staff, many citizens hired on as short-term laborers. Although the caption is difficult to read, it appears that this photograph includes Adair Mathews, Bubles Oneys, Perry Keithley, Captain Shoemaker of the Salvation Army, and Floyd Isbell, a local laborer. (Courtesy of the *Monett Times*.)

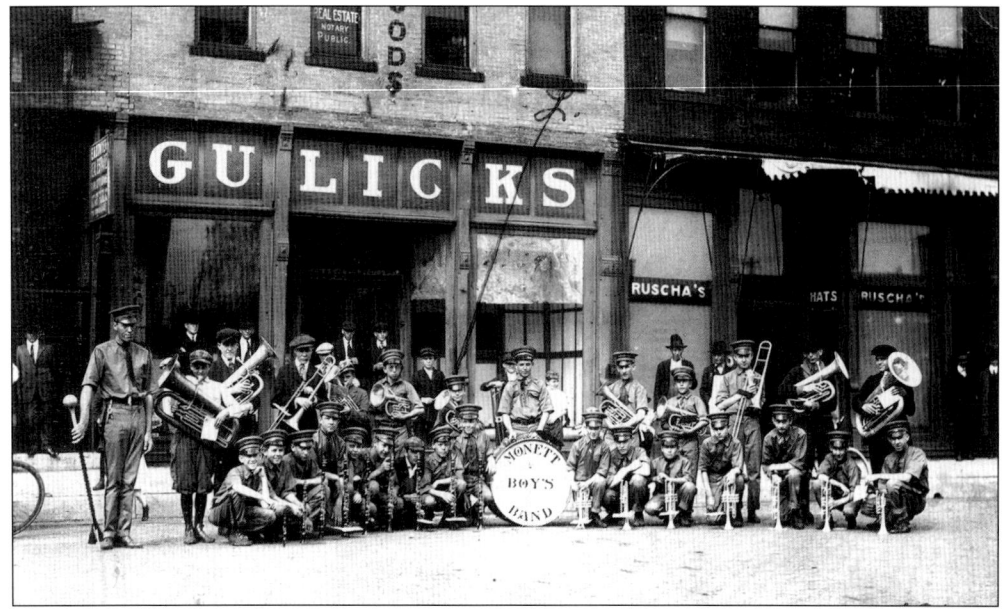

The Monett Boys Band is pictured in 1920, with Homer Lee as director and John Leonard Roberts, business manager. J. H. Gulick opened his store on Broadway between Third and Fourth Streets in 1910. Its large display windows featured the newest in men's and boys' clothing, and the large stock drew shoppers from throughout southwest Missouri. (Courtesy of the Monett Library collection.)

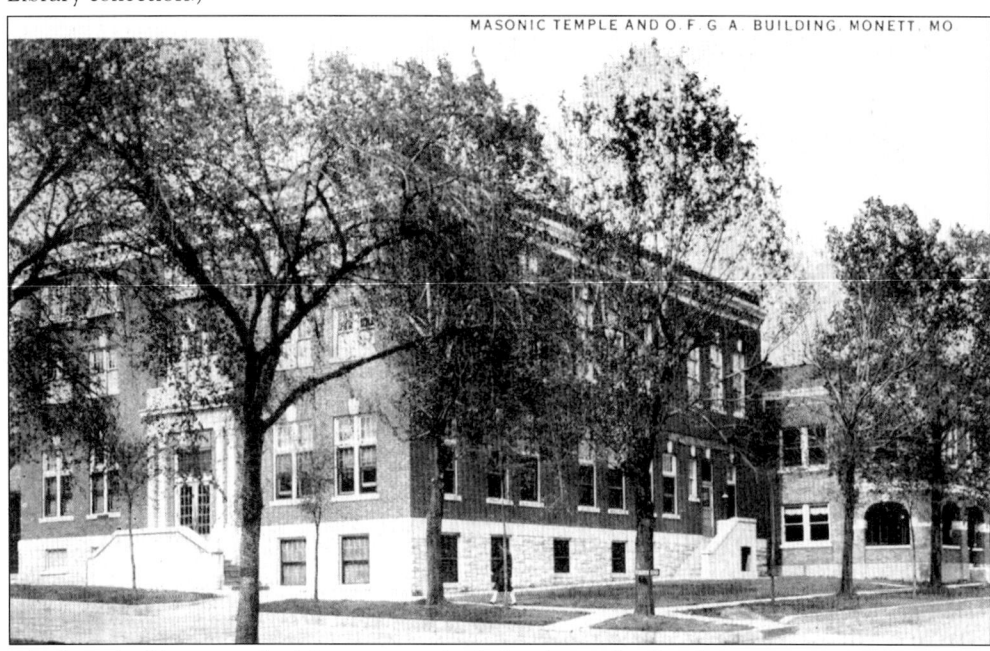

The large building was the Masonic temple. Behind it is the Ozark Fruit Growers Association building, which was on Bond Street between Fourth and Fifth Streets. The second floor was a large auction room that was most used during strawberry season. Both buildings remain; the temple is now a church, and the fruit growers' building is an apartment house. (Courtesy of the collection of Rod Anderson.)

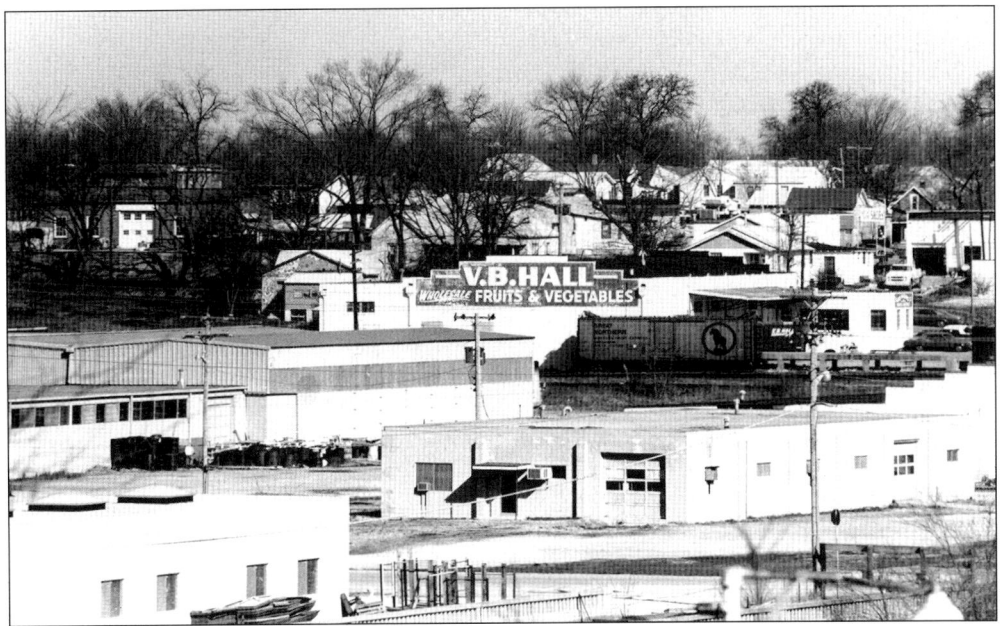

Viga B. Hall (called V. B.) built Hall Fruit and Vegetable Wholesale Service near the railroad for easy shipping. He opened in 1919, after leaving the military, and later served as Monett's mayor. Recognizing the need to diversify the town's economy, he led the effort to establish the MIDC, which brought in Vaisey-Bristol Shoes and window maker EFCO, which became major employers. (Courtesy of the collection of Rod Anderson; photograph by Ed Shideler.)

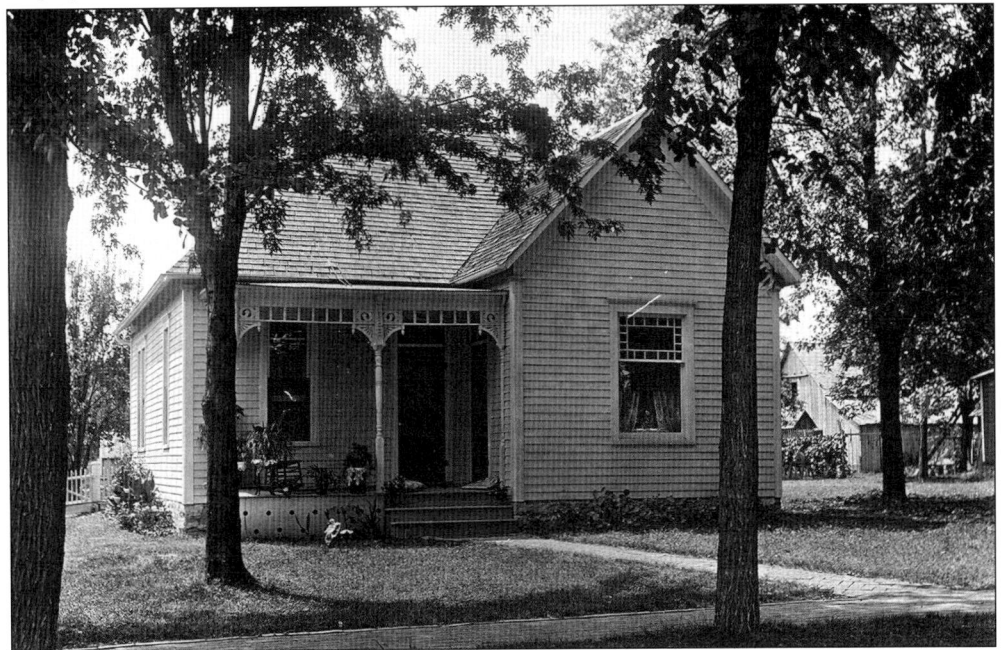

There were many elegant homes in what is now downtown Monett, but most were more modest structures. While the barn in the back indicates that this house may have been on the edge of town in the early 1900s, its location was probably no more than a few blocks north of the railroad tracks. (Courtesy of the Monett Library collection.)

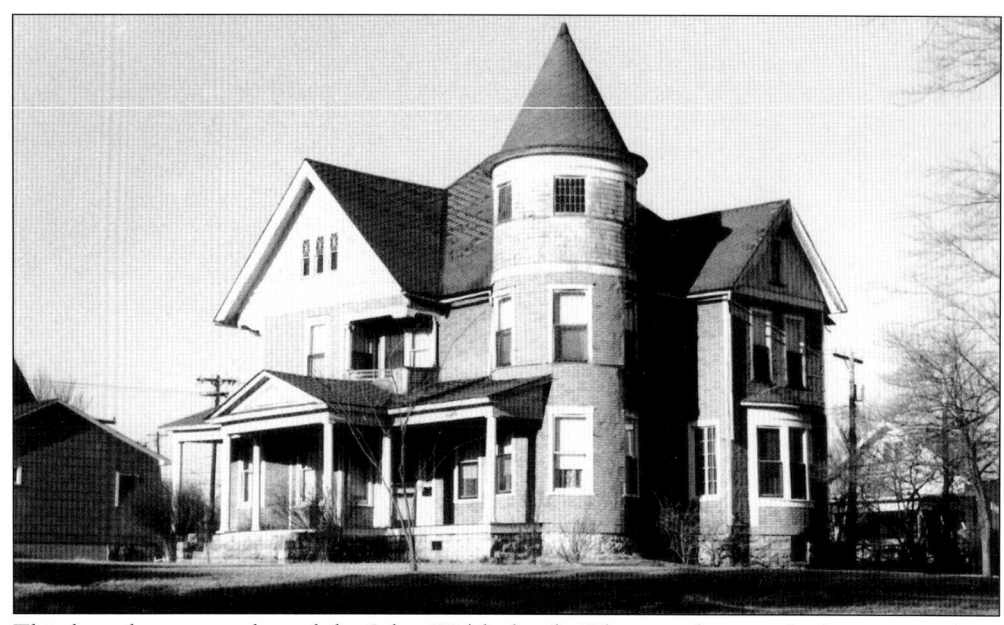

This large home was that of the John Walsh family. The top photograph shows it in about the 1940s or 1950s, when it had moved beyond its initial heyday. The lower photograph shows it restored in 2006, with a wraparound porch again in place. John Walsh bought his grocery store, which stood on Broadway between Fourth and Fifth Streets, in 1888. He also served as president of Central State Bank, which opened in 1919. During his two terms on the city council, he led efforts to build a municipal light plant (as electric plants were called then) and get Broadway paved with bricks. (Top photograph courtesy of the Monett Library Collection; lower photograph by Elaine L. Orr.)

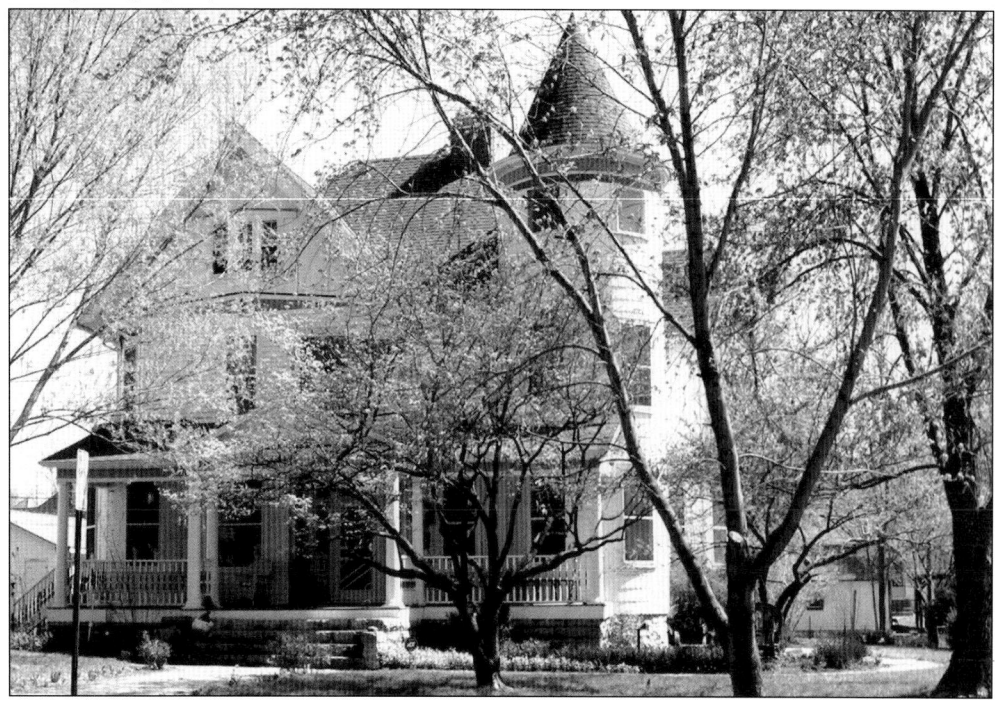

This elegant-looking display is that of an automotive supply parts dealer. It may have been in the local Ford Dealer, as Ford parts are visible. The men are unidentified. (Courtesy of the collection of Rod Anderson; photograph by Ed Shideler.)

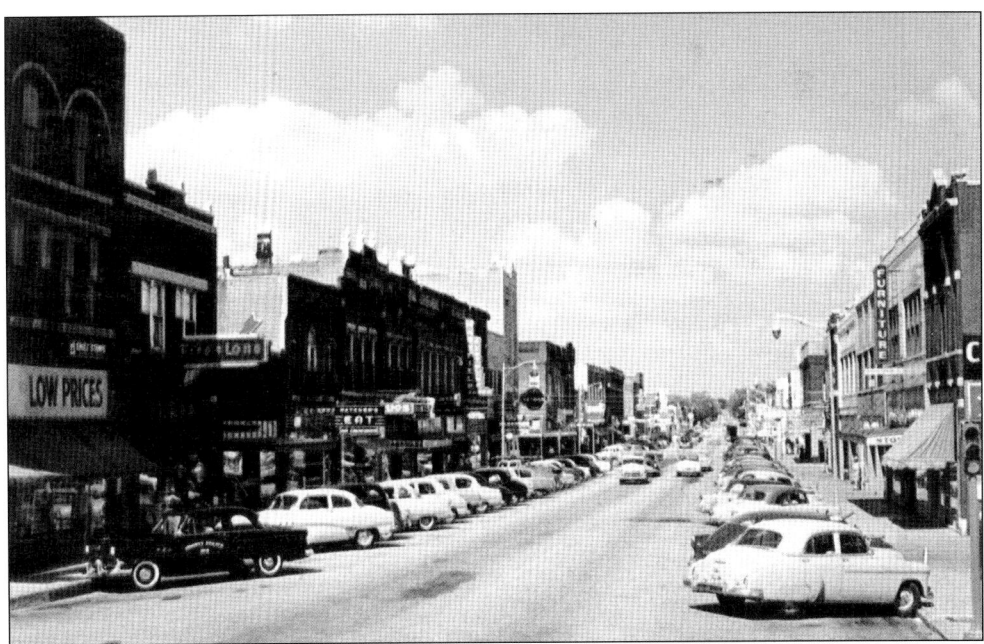

Looking east on Broadway in probably the late 1950s, there is a taxicab parked on the left. Also on the left is Mansfield Shoes, which is still in business. (Courtesy of the collection of Rod Anderson; photograph by Ed Shideler.)

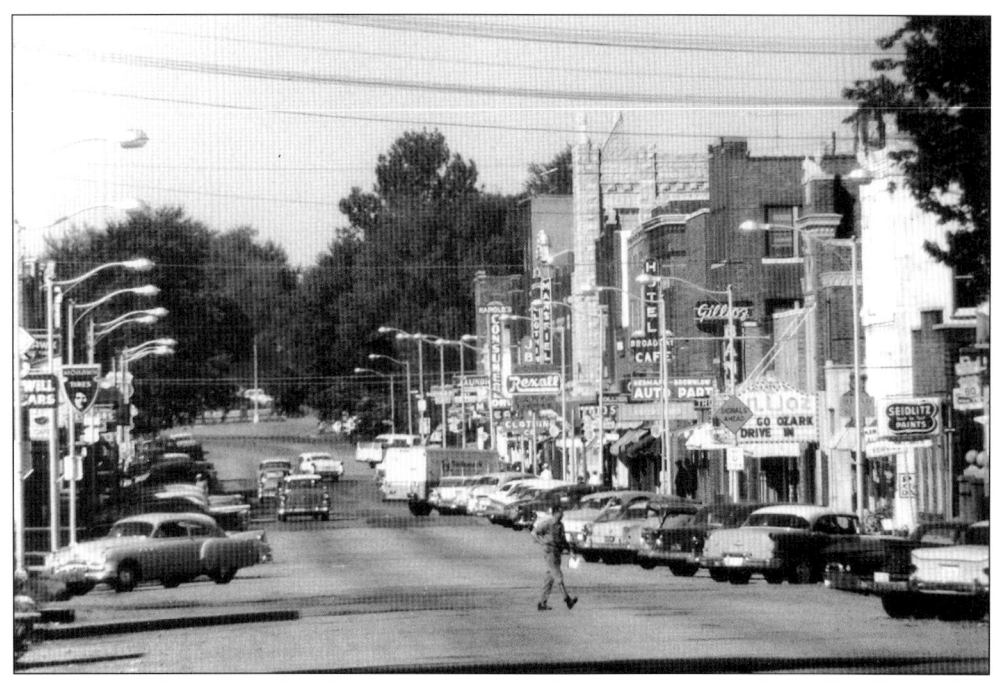

Modern streetlamps dot Broadway in this view looking west later in the 1950s. The Gillioz Theater is on the right, and next to it is the café of the Broadway Hotel, successor to the Attaway and one of the first brick hotels in town. The treed area at the end of the street is now developed. (Courtesy of the collection of Rod Anderson; photograph by Ed Shideler.)

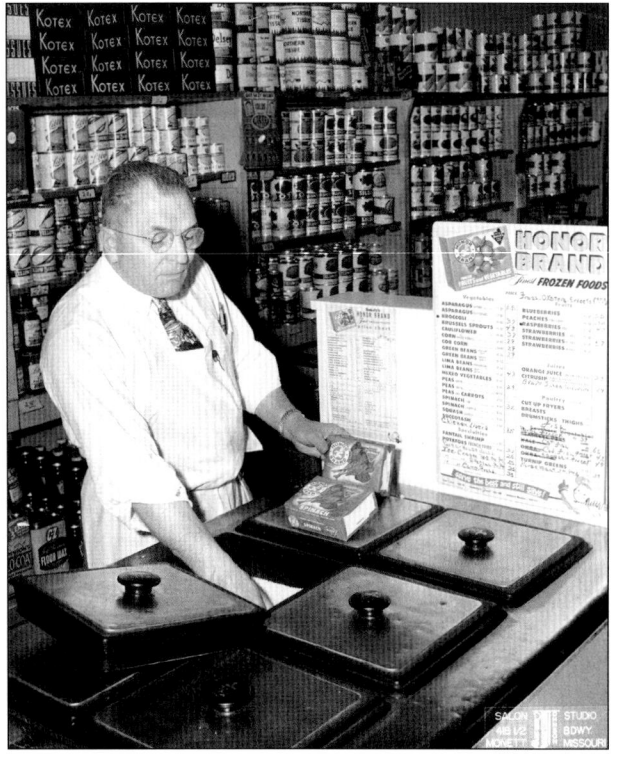

The frozen food case in front of this grocer is a far cry from having to keep foods cold with ice from the Railway Ice House. The signs show that a pound of fresh strawberries was 57¢ and a pint of ice cream was 25¢. (Courtesy of the *Monett Times*.)

Enid Owens (née Amos), daughter of a longtime Monett family, worked in several restaurants downtown. She is shown here not long before her sons were born. Note the cases for Coke bottles next to her. (Courtesy of Keith Owens.)

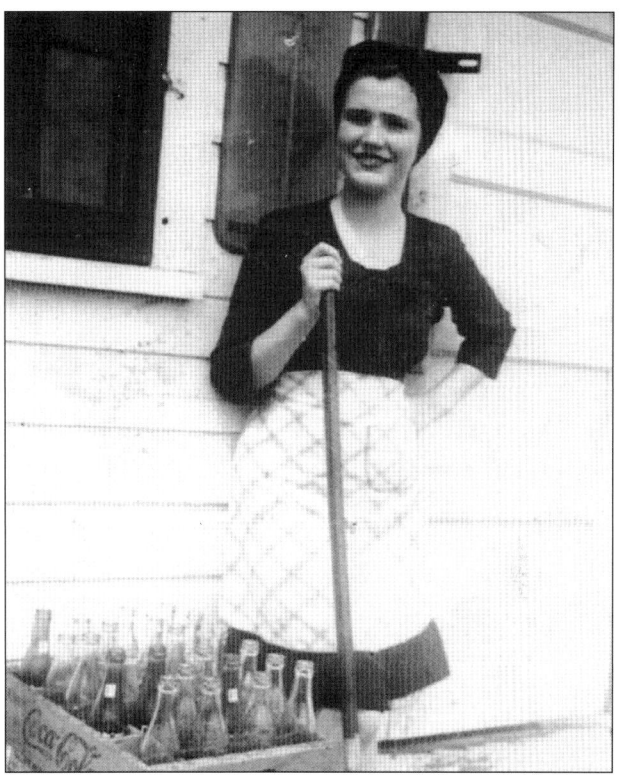

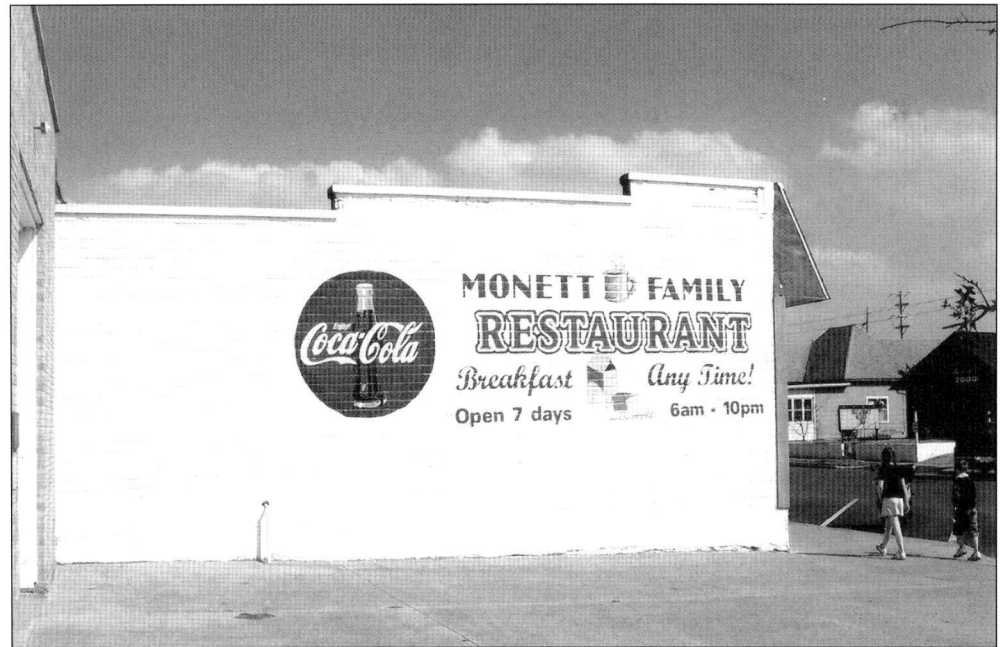

Coca Cola is still prominent, this time advertised on the side of the Monett Family Restaurant. It is on Broadway, a popular spot for those who work downtown or come in for business. It is open from early morning to late in the evening, and there are always people ready to provide tips to an amateur historian. (Photograph by Amy Newbold.)

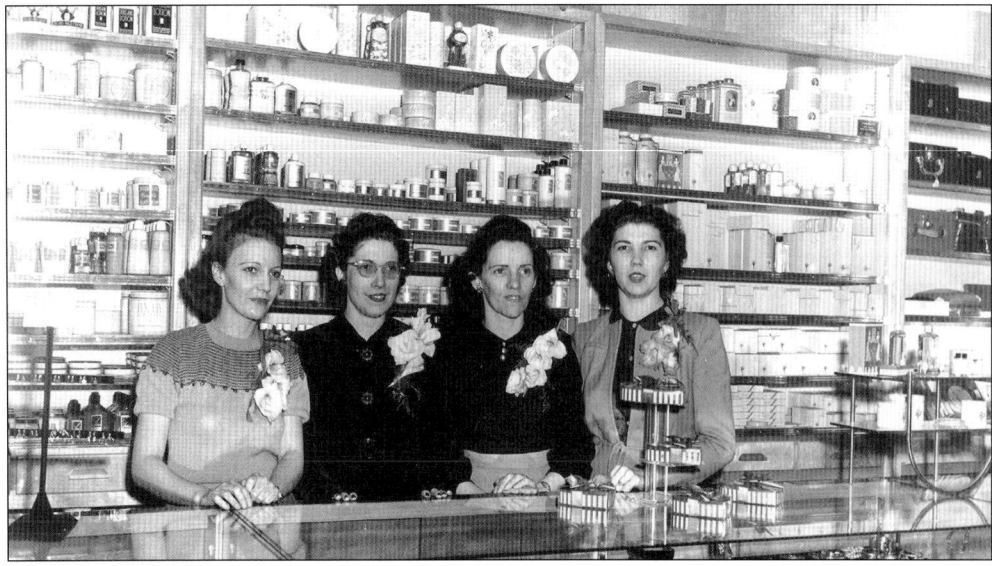

McShane's Rexall Drug was on Broadway and carried everything from drugs to leather goods to perfumes. This photograph gives a sense of the fine wood and stylish décor. (Courtesy of Rod Anderson.)

These women worked at McShane Drug and are pictured in front of its elaborate display of perfumes and other toiletries. On the far right is Dorothy Anderson (née Medlin), and second from left is her sister, Audrey Millikan (née Medlin). (Courtesy of Rod Anderson.)

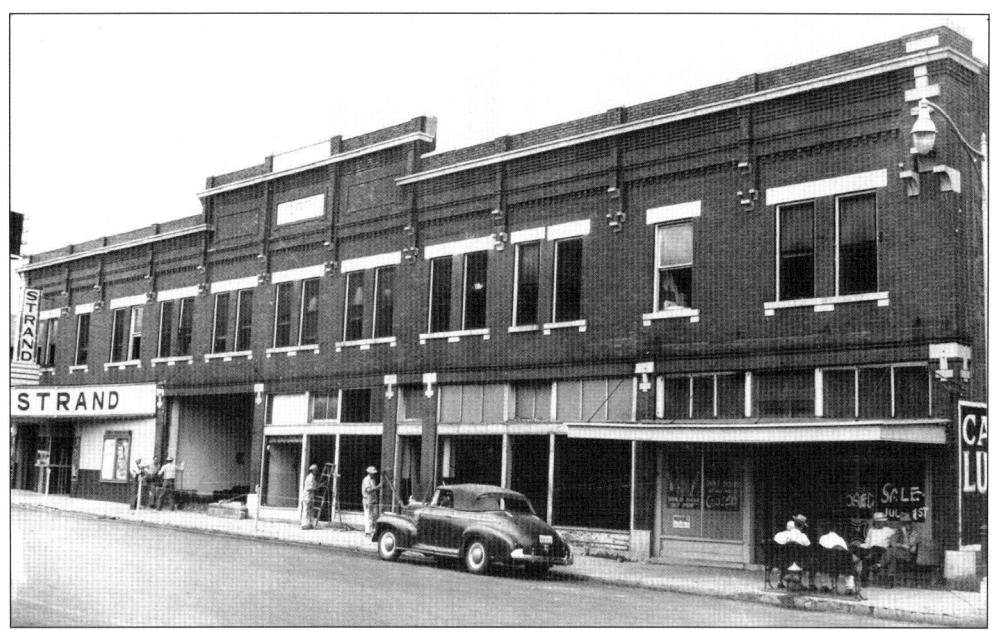

The Martin Hotel, shown here after it closed, was built in 1910 and stood opposite the Frisco Depot on Fourth Street. Its advertisements said it had steam heat and many rooms with private baths. The café was geared to railroad travelers and was thus open late. Proprietors were Ernest Boss and his brother-in-law, Mr. Gabriel, who were in the hotel and restaurant businesses in Monett for many years. At the far end is the Strand Theater. (Courtesy of the *Monett Times*.)

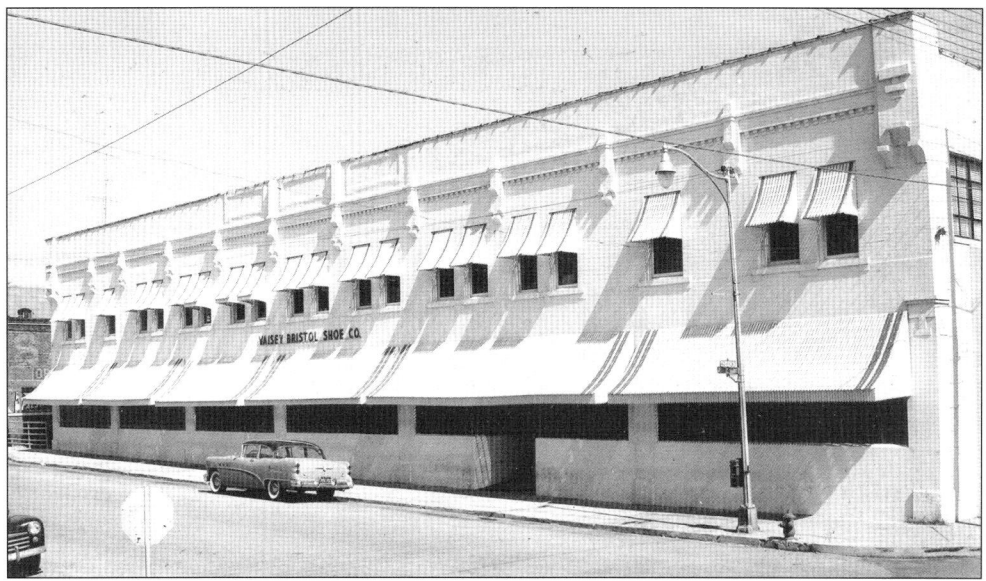

The remodeled Martin Hotel became the Vaisey-Bristol Shoe Company, which moved to Monett in 1947. For many years in the early post-Frisco era, it was the town's largest employer (with an annual payroll of $2 million in the mid-1960s). Production eventually moved overseas. Many of the 400 former employees and their descendants still live in the town. (Courtesy of the *Monett Times*.)

Then-governor John M. Dalton inspects a recently made shoe during a 1964 visit to the Vaisey-Bristol factory. (Courtesy of the *Monett Times*.)

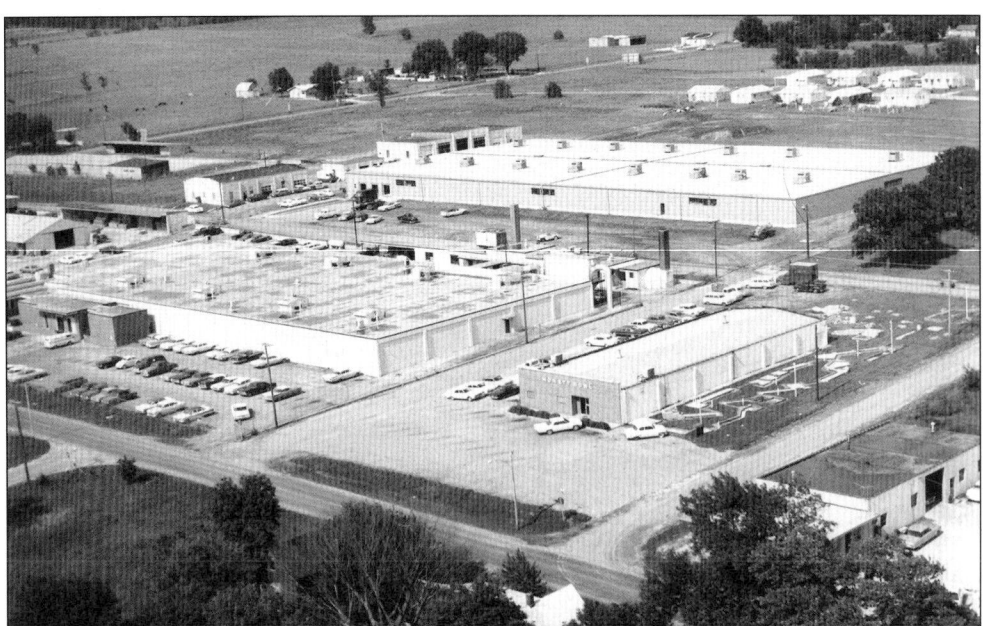

Vaisey-Bristol Shoes, which makes the children's Jumping Jack brand, built its modern warehouse near its factory in Monett in 1965 to consolidate its inventory. Prior to that, shoes were stored in several locations, including the old Central School. The old bowling alley is on the right. (Courtesy of the *Monett Times*.)

This aerial shot was on the cover of the Monett Chamber of Commerce brochure in the early 1960s. The young baton twirler is Paula Lee, a 1969 Monett High School graduate and daughter of Homer and Adola Lee; Homer was the key mover behind the Monett American Legion's twirling camp that was held each summer for more than a decade.

Monett was losing the Frisco Railroad about the same time that EFCO Corporation was looking for a new home. It signed an agreement with the Monett Industrial Corporation to finance and construct an 18,000-square-foot plant, which began operating with 25 employees on November 8, 1958. This aerial view was taken a number of years later. (Courtesy of the collection of Mark Henderson.)

New buildings stand next to old in downtown. Annie's Attic—an antique shop and tea garden—and Huffmaster Insurance are in the 200 block of Broadway. Kevin Huffmaster is the brother of one of the Frisco beauty pageant winners on the cover of this book. (Courtesy of the Monett Library collection.)

This 134-acre complex in Monett houses the headquarters for Jack Henry and Associates, which provides computer systems and ATM networking products for banks and credit unions. The concept behind this firm that employs more than 1,200 people in nine states was outlined on a napkin a few miles from Monett. (Courtesy of Jack Henry and Associates.)

# Three

# A Few People Make a Difference

Every town has people who stand out as special contributors to business, health care, or just good community spirit. This chapter highlights several of Monett's early citizens. There are surely others who deserve such attention; many are noted in other chapters of this book.

Ed O'Dwyer was a leader in the agricultural economy and helped protect the citizens of Barry County as well as Monett. Ed Shideler took many of the photographs in this book, but he was also something of an inventor who always looked for better ways to do things. Logan D. McKee was a pharmacist by training and an aviator at heart—and his heart was a big one.

Fielding P. Sizer Sr. was much more than an attorney. M. E. Gillioz constructed key buildings and some of the town's infrastructure, but he was much more than a builder or banker. His personal and physical imprints remain strong.

The pioneer women who settled Monett with their families were adventuresome souls, but it is always difficult to find written materials that describe them other than as their husband's mates or contributors to their churches—important roles, of course. Still, it is harder to find their contributions in print.

Pearl Peters took over as publisher of the *Monett Daily Times* after her father's death in 1917, and her dedication helped it survive the business slump associated with World War I. Nellie Mills taught school for many years and recorded much early history. Her influence on several generations of Monett's children was profound.

When Ed A. O'Dwyer, a former Barry County schoolteacher who was born in Canada, came to Monett in 1897, he was in real estate, farm loans, and insurance. He served as chief of police of Monett from 1924 to 1925, was a strawberry farmer and president of the Ozark Fruit Growers' Association, and served as a justice of the peace in Monett Township. For a time, he was the sheriff of Barry County. (Courtesy of the Monett Library Collection.)

Attorney Fielding P. Sizer left Frisco when it urged him to stop advocating the temperance movement. Shippers thought this was bad for business. Sizer went on to defend some Frisco employees in lawsuits and represented others who believed they had been wronged by the railway. He survived the Frisco's attempt to have him disbarred. (Courtesy of the collection of Rod Anderson.)

The Sizer family named their home Callamura, and it was the finest in Monett. It is just as elegant in 2006 and contains some of the original furnishings. (Courtesy of the collection of Rod Anderson.)

Nellie Mills taught first at Central School, beginning in 1897, and then as the business teacher in the high school. She wrote the *Early History of Barry County* and was active in the Presbyterian Church, where she taught Sunday school. This cookbook, which the *Monett Times* later republished, was a way to engage her students. The advertising in it also serves as a piece of history.

# Monett Cook Book

Tested Recipes Collected, Arranged and Published by

*Miss Nellie Mills' Class*

of the

*Presbyterian Sunday School*

MONETT, MO.

FIRST EDITION MARCH, 1910
SECOND EDITION DECEMBER, 1929

Logan D. McKee built this DeChenne airplane in a garage in Monett and flew it during the July 4, 1911, celebration locally and traveled to air shows throughout the Midwest. In his pharmacy, he also had equipment to produce postcards from photographs. This business effort combined with his interest in photography to create many of the postcards that survive today, especially those published in 1908 and 1909. (Courtesy of the Monett Library collection.)

McKee is shown here in his original DeChenne plane, which was housed in the garage in which he built it. By this time, he had served on the Monett School Board for nine years, as president of Monett's Commercial Club, as an active Kiwanan, and as chairman of the North Barry County Red Cross. (Courtesy of the collection of Rod Anderson.)

Without Ed Shideler's photography, there would far less a record of Monett's first half of the 20th century. When away from Monett one time, he heard a radio for the first time. He returned to town and built the first one in Monett—then he hung speakers (made out of old oatmeal containers) on a tree so his neighbors could hear the shows. (Courtesy of the Shideler family.)

Ed Shideler is shown with his wife, Irene Beck Shideler. They usually did not own a car, but drove through Monett with Ed on a motorcycle and Irene and their daughter, Sadie, in a sidecar. (Courtesy of the Shideler family.)

M. E. Gillioz and wife Esmarie Maret (called Mary by some) are pictured in their youth. Adults either remember or have heard from their parents about the man who gave a quarter to each child who came to his movie theater (which opened in 1931) on days near Christmas—an amount of money that meant a lot during the Depression. (Courtesy of Helen Gillioz Reynaud.)

By the time M. E. Gillioz posed for this photograph, it had been a long time since he had to drive the equipment himself. He is still known for having built bridges and many other structures throughout southwestern Missouri and northern Arkansas. (Courtesy of Helen Gillioz Reynaud.)

The board of directors of the Monett Chamber of Commerce made M. E. Gillioz the "Outstanding Citizen of the Year" soon after he opened a drive-in bank of the Gillioz Bank and Trust Company on July 25, 1950. From left to right are (first row) Hub Ellis, Gillioz, and Dick Padgham; (second row) George Sheehan, Leslie Mason, Raymond Magerstaedt, Tommy Young, Kenneth McShane, Dave Dillon, L. G. Jones, Clyde Combes, and A. K. White. (Courtesy of Helen Gillioz Reynaud.)

A stone monument is perhaps a fitting memorial for a builder, but it cannot capture the depth of Gillioz's contributions. He died in 1962. From left to right are members of the Monett City Council—Lewis Skaggs, Albert McIntyre, and Albert Rose—as well as attorney Edward Sweeney and Esmarie Maret Gillioz. (Courtesy of Helen Gillioz Reynaud.)

The former Monett Times building is now the Monett Police Station. Pearl Peters is second from the right. She and her sisters began gathering the news in 1899 for what was initially a weekly newspaper, so when she became editor and publisher upon her father's death in 1917, she was an experienced newswoman. Her slogan was "all the home news," and she urged her staff to work as hard as she did to find it.

This advertisement for the *Monett Times* appeared in the 1938 city business directory (which M. E. Gillioz largely funded).

### The Monelt Times

The Family Newspaper

Something interesting for every member of the family, young or old, in every issue. CLEAN, READABLE, UP-TO-DATE.

#### THE MONETT TIMES
##### DAILY EDITION

| | |
|---|---|
| Per month by carrier | $ .50 |
| Per 3-months by carrier | 1.25 |
| (Cash in Advance) | |
| Per year by carrier | 5.00 |
| (Cash in Advance) | |

##### WEEKLY EDITION

| | |
|---|---|
| Per Year | 1.00 |
| Local Advertising rate, inch | .25 |
| Foreign Advertising rate, inch | .30 |

Serving Monett, Barry and Lawrence Counties for 39 Years.

### Times Publishing Company

Pearl Peters, Editor and Publisher.

## *Four*
# CLIMATE OF EXTREMES

Southwest Missouri can have mild winters and then a foot of snow in March, or winters can produce bitter cold and a series of ice storms. Spring and summer bring a constant awareness that a tornado could be just around the corner. Pierce City, which had been the Frisco division point before Monett, had its entire business district destroyed by one in May 2003. While Monett has had some on the outskirts of town (including the 2003 one that hit Pierce City), downtown has never been hit.

Harder to capture in photographs is the summer heat. It does not take a drought for people to feel parched throughout July and August and well into the fall. The pool in Monett's City Park is popular all summer. In larger cities, people think of droughts as imposing restrictions on watering their lawns. In a town like Monett, a dearth of rain affects the area's farmers and can have some impact on the local economy.

Some things never change. Kelly Creek continues to flood downtown every few years. While the water is generally not very deep, it seeps into businesses and is made more damaging to them by cars that drive by and create a wake. Business owners are adept at placing sandbags at any point where water can enter.

Kelly Creek was paved through town as part of a Works Progress Administration project during the Depression. There have been other engineering efforts to tame the effects of the heavy downpours that the town sometimes gets, but some observers say Monett has not wanted to spend the large amount it would take to end the problem.

When trains keep moving on the tracks, snow may not accumulate, but let the rails be idle, and snow piles up. Snow this deep appears to have been something of a novelty, as most of these men are in their usual business attire rather than outfitted for the weather. (Courtesy of the Frisco Meteor Man.)

Kelly Creek, while high, looks peaceful in this photograph, which was probably taken about 1910. (Courtesy of the Monett Library collection.)

This 1919 view looks south from Broadway, with a train operating in the distance despite the water. Children are leaning out of a door, looking at the photographer. (Courtesy of the Monett Library collection.)

In 1928, water had ventured two blocks to the former opera house, where a car appears to have stalled. (Courtesy of the *Monett Times*.)

49

In 1943, water is again on Broadway. The men in raincoats in the street are police officers. Gillioz Clothing is on the left, with the McShane family's Rexall Drug next to it. The photographer captured the reflection of some of the buildings. (Courtesy of the collection of Betty Steele; photograph by Ed Shideler.)

Red Skelton opened in *Ship Ahoy* in 1942, and it appears to be an appropriate film for the occasion. Given the child on a bicycle and people on the sidewalk, either this flood was not as bad as some others or it had receded. (Courtesy of the collection of Rod Anderson; photograph by Ed Shideler.)

In 2004, water again reached downtown, although storm drains in some parts of town handled the almost six inches of rain better than others. The people in this photograph, including a firefighter, hold onto a rope as they cross the street. (Courtesy of the *Monett Times*; photograph by Murray Bishoff.)

Neighbors have come to view the damage after a June 17, 1909, tornado hit Andy McCormick's farm, south of Monett. It must have had a wide path, for the same photographer also took pictures at the farms of D. S. Courdin and J. G. Knotter. Whether it actually was a cyclone (in which winds rotate counterclockwise) or the photographer used this as a general term is not known. (Courtesy of the Monett Library collection.)

This tornado appears to have hit in the late 1940s or early 1950s. As if to illustrate how seemingly selective their damage can be, the tornado destroyed this house while the one next to it appears not to have been damaged. (Courtesy of the collection of Rod Anderson; photograph by Ed Shideler.)

The pain of a tornado's damage is shown not just by the cast on this man's arm but the downcast expression on the young man in the Cub Scout hat, who is being comforted by a friend. (Courtesy of the collection of Rod Anderson; photograph by Ed Shideler.)

# Five
# AT HEART A RURAL COMMUNITY

In Monett's earliest years, townspeople had chickens and perhaps a cow or two in a small barn in their backyard. The barn was essential to house every family's favorite means of transportation and the buggy it pulled. Nearly every home had a large vegetable garden.

An Easterner cannot truly understand what it is like to go "outside of town" in the Midwest. From northern Virginia through southern Massachusetts there is usually little distance between towns; in many areas, travelers cannot tell when they leave one jurisdiction and enter another because homes or strip malls run together. That is not the case in Monett. When one leaves the city limits there are either fields of hay and corn or herds of grazing dairy cows. One can still drive for miles without reaching another community.

Monett is a busy place with its share of stores and restaurants. No one has chickens in the yard, but Tyson's Foods, a poultry processor, and Shreiber Foods, a dairy products producer, are major employers. Another sign of change is that tucked among the fields is an airport that handles private planes and the many corporate jets that serve Monett's industries.

Many residents continue to enter their vegetables or animals in the Barry County Fair and hope to be able to go on to the state fair. Broadway still has a firm that services harnesses, bridles, and other leather goods. Perhaps best of all, even downtown is close enough to "the country" that the air is always fresh.

THRESHING WHEAT IN MONETT TWP. BARRY CO. MO. 1909.

A small steam engine powers the threshing machine in this 1909 photograph. The hay is spewed into large mounds that will quickly be separated so that it does not become too moist. Today machines create bales or rolls of hay that farmers protect with plastic. (Courtesy of the Monett Library collection.)

WE HAVE GOOD CYCLONES TOO NEAR MONETT, MO.

Farmers work with pitchforks, and horses stand ready to pull wagons of hay. It is not clear why the photographer has referred to cyclones, unless this picture was taken when he was searching for damage from a recent one. (Courtesy of the Monett Library collection.)

The Patterson Mill was just south of the railroad tracks so that the grain it processed could be easily transported. The mill opened in 1905 with a capacity of 200 barrels of flour or other processed grain per day. The buggy in the photograph is likely there to pick up flour, as it is too fancy a vehicle (and too small) to be dropping off grain for milling. (Courtesy of the Jeffries Collection.)

This photograph was taken about 1911 on the Alba Banks farm, which was southwest of Monett. From left to right are the children of Alba and Ada Banks (née Fleetwood): Stella, Mabel, Alba, and William Banks. The farm is still in the Banks family and is a designated Missouri Century Farm. (Courtesy of the Jeffries Collection.)

The crates in front of this group hold some of Monett's famous strawberries. This appears to be a house near town, since the family has set up a small stand to sell the berries. The windmill in back indicates the house was probably not attached to a city well. (Courtesy of the collection of Rod Anderson; photograph by Ed Shideler.)

The Ozark Fruit Growers Association used this emblem for a number of years, beginning in 1936. Another one touted grape production. By the early 20th century, Monett growers shipped their berries to 38 states and Canada. The region is now known more for its grapes, used for locally produced wines, than its strawberries. (Courtesy of the collection of Rod Anderson.)

Cars were such a novelty that families often posed in front of them when a visitor brought one. Two of the people in this photograph are Walter Hall and Lucinda Hall, who were related but not married to one another. (Courtesy of Keith Owens.)

Taken in the 1920s, this photograph is of Thomas Banks with the milk truck he drove for his uncle Orville Pruitt. (Courtesy of the Jeffries Collection.)

This photograph was taken on farmland just outside Monett. Given their dress, the men appear to be "city folks" visiting the country rather than farmers. (Courtesy of the Monett Library collection.)

Ed Shideler and Bill Ezell often took photographs together. Ezell was a custodian at Monett High School. This photograph shows how distant the farms in Lawrence and Barry Counties were from one another in about the 1930s. (Courtesy of the Shideler family.)

# Six
# Civic and Government Life

Monett's first mayor was S. J. Cordin, and names of early mayors and city councils include familiar ones in local business—L. B. Durnil of the dry goods business, grocer John Walsh, Dr. T. H. Jeffries and his son Leroy, and J. U. and Burl Vermillion, to name a few.

While citizens see the city "do projects" today, it is hard to imagine building the infrastructure from nothing, as the town did in the early part of the 20th century. The first major deep-water well was sunk in 1902, and the city got into the electricity business in 1911. Road building was a major undertaking within towns and between them.

The city's police department is mentioned much earlier in publications than its fire department, which appears not to have formed until after 1900. However, there must have been a volunteer squad, because there are a few photographs of fires that appear to be earlier and in which a large hose can be seen.

Monett is in two counties, Barry and Lawrence, with the business district in Barry. Until the mid-1930s, no Missouri town could be in two counties. After the law changed, Monett held a special election and voters approved annexing Forest Park, which was in Lawrence County. It became part of Monett in December 1934. The bicounty geography adds some challenges, but for the most part, things work smoothly. The county line is Cleveland Street, named for the then–newly elected president.

There are countless civic and fraternal organizations, many of them formed very early in the town's history. In the colorful language of early publications, their members are often referred to as town "boosters" or "wide awake citizens."

Lawson Jeffries was Monett's first fire chief, about 1905–1910. Lawson was the brother of Leroy, who owned stores, service stations, and early car dealerships in Monett. The emblem on the hat says "Chief," and the ribbon says "Annual Meeting, Southwestern Firemen's Association, Webb City." Lawson later owned a grocery store and pool hall and managed the town's semiprofessional baseball team. Around 1910, he started a coal business, which eventually expanded into a substantial hauling concern. (Courtesy of the Jeffries Collection.)

Joe Jackson rose from the rank of night watchman in 1902 to police chief. Monett was not an easy town to police because of the many transients who traveled the railroad, and Jackson was a formidable presence. In 1922, he became a deputy U.S. marshal. (Courtesy of the Monett Library collection.)

This is the interior of the former post office building. The man in the rear on the right is probably Samuel A. Chapell, who served as mayor from 1918 to 1922 and was on the school board. He was also a partner in Davis and Chapel Hardware. On the floor above this post office was Dr. William West's first medical office. (Courtesy of the *Monett Times*.)

The poll tax was used in many states as a means to keep black citizens from voting. This receipt shows someone worked two days to pay the 1898 tax; black residents probably could not do so. In any event, most black people left Monett when a black man was lynched in 1894. As recently as the 1950s, when trying to attract new businesses, Monett presented itself as "6,000 people, all white." The 21st-century Monett is a more diverse city.

These two women and a boy at first appear to be simply out for a ride in June 1908. A closer look shows that the boy's hat says "vote for . . ." The name is not readable. (Courtesy of the Monett Library collection.)

This building is referred to as the new Elks Home in Monett, which is said to have opened in 1911. The Elks were well known for their musical talents, which were featured in parades, local plays, and band concerts. (Courtesy of the collection of Mark Henderson.)

This is thought to be Joe Cannon, speaker of the U.S. House of Representatives from 1903 to 1911 and a member of Congress for all but four years between 1873 and 1923. The background shows the southern areas of Monett have begun to develop more than they did in the early years of the city. This is also an excellent photograph of the roundhouse. (Courtesy of the Monett Library collection.)

Theodore Roosevelt is said to have whistle-stopped through Monett on more than one occasion. This September 23 photograph was taken during his 1912 campaign for president on the Progressive ticket. He has drawn the attention of Monett citizens as well as those on a passing train. (Courtesy of the Jeffries Collection.)

Monett has contributed many citizens to the Missouri National Guard. This photograph of the local company was taken in 1930, as the men of the 203rd Battery were in Nevada, Missouri, for exercises. Monett's new National Guard armory was dedicated in 1991. (Donated to the *Monett Times* by Bill Bridges.)

Pres. Harry S Truman, a native Missourian, dedicated the new hall of the American Legion in 1948. What one cannot discern from this photograph is that he did so in the back of a train that stopped in Monett. The man at the far right is the American Legion commander. (Courtesy of the collection of Rod Anderson.)

City hall is pictured, probably in the 1930s. By that time, it also contained a library, which the city council had agreed (in 1926) could be in one room in the building. It was so popular that in 1927 there was a special election, which passed, to provide city funds for it. The library is now in a modern facility less than a block away. (Courtesy of the collection of Rod Anderson.)

Former police chief James A. Johnson tips his hat as he enjoys retirement. He was the chief before the officers had cars for patrol. His granddaughter says that he could control the town while standing at the corner of Fourth Street and Broadway. (Courtesy of Peggy Pinnell.)

Cecil Long (1901–1969) worked first as a fireman on the Frisco Railway. His public service career included serving as Monett city clerk in the early 1930s, Barry County recorder of deeds from 1935 to 1950, and state representative from Barry County from 1951 to 1957. He is shown here in the Barry County courthouse as recorder of deeds with his deputies Blanche Snider (left) and Ruth Sullivan. His wife was Trink Jeffries, daughter of Monett pioneer Leroy Jeffries. (Courtesy of the Jeffries Collection.)

The photograph of a car in a Monett parade would have been taken during World War II, when the government heavily promoted citizen purchases of war bonds. (Courtesy of the collection of Rod Anderson; photograph by Ed Shideler.)

Dan R. McDonald served as Monett's police chief from 1936 to 1959. He wrote for several law enforcement journals, and one article was reprinted in the *International Criminal Review*. As a Marine Corps veteran, he was twice commander of Monett's Hobbs Anderson Post 91 of the American Legion. (Courtesy of the American Legion.)

This photograph of Monett's police department is from 1963. From left to right are (first row) Leonard Mullicane, H. E. Roberts, Oren Davis, Asa G. Steele, and Joe Kenney; (second row) dispatcher Dick Harner, Charley Tate, Frank King, Joe Bodecker, and dispatcher Walt Campbell. (Courtesy of Betty Steele.)

The Monett American Legion post won a national Fourth of July contest in the mid-1970s with a scrapbook that described how the holiday was celebrated in a local community. Shown receiving the $100 prize are, from left to right, Calvin Cloud, Taylor Hopkins, state legion commander Kenneth Tucker, Willis Moreland, Ray Langford, and Dick Brady. (Courtesy of the American Legion.)

Judge William H. Pinnell of Monett was a longtime circuit court judge in the three-county 39th Judicial Circuit. He graduated from Washington University School of Law in 1947 and became the youngest lawyer in Missouri. Pinnell presided over more than 30,000 criminal, civil, and juvenile cases and refused to wear robes in court, believing it was ostentatious. (Courtesy of Peggy Pinnell.)

# *Seven*
# SCHOOLS AND SPORTS INTERTWINED

The first Monett public school opened in March 1888. Earlier area schools required that students pay to attend. There was one named Conscription School that the Frisco moved when it built the first tracks in the area. The school system may have contracted for a photographer in 1909—possibly Logan McKee or Ed Shideler—because there are postcards of all of the schools that year.

Many sports programs relate to the schools. Monett High School (MHS) is a Triple A School and is a member of the North Central Association of Colleges and Secondary Schools. The town had a semiprofessional baseball team as early as 1908. Such teams would play in other towns, and while they may have traveled to nearby Arkansas, the cost of travel would not have sent them on the road too often.

The Monett Board of Education established the Monett Junior College in 1927, and many teachers and business leaders graduated from there. It shared campus space with the high school. World War II hastened its demise because so many young men went into the service.

High school football games are always popular. The Monett Library has postcards of early games. The referees are in coats and ties, and the players wear almost no protective gear. In 1968 and 1969, the MHS boys' tennis team won the Big Ten championship.

Although girls' athletics were not as common in the early years, there are photographs of a women's basketball team in about 1910. In 1975, girls' athletics began participating in the Big Eight Conference, which brought more respect to girls' sports. Jane Rogers was the first interscholastic team coach at MHS.

Central School, built in 1890, was in the heart of downtown Monett and was a landmark in many photographs for about 70 years. If school was in session this day it must have been a special occasion, as students probably did not climb the utility poles on a regular basis during lessons. (Courtesy of the Monett Library collection.)

St. Joseph's School is pictured in 1901. This was the school for St. Lawrence Catholic Parish, and it opened in September 1895. It was named for the Sisters of St. Joseph, who taught at the school. (Courtesy of the Monett Library collection.)

The junior class of MHS is pictured in 1909. (Courtesy of the Monett Library collection.)

The MHS girls' basketball team is pictured in 1909. This may be a formal team, or could be a high school class. Other accounts say the girls' team did not form until 1916. (Courtesy of the Monett Library collection.)

Forest Park School is pictured, probably in 1909. It was the focal point of this rural community in Lawrence County, Missouri, which Monett annexed in 1934. The schoolhouse was built in the 1890s. (Courtesy of the Monett Library collection.)

Martin's White Sox are shown here in 1908. Earl Jeffries is in the center of the back row. On July 31, 1908, the *Monett Times* gave the lineup of the Martin's team as Charles Woolsey, catcher; Rex Leckie, pitcher; Frank Geister, first base; Tom Lyons, second base; Lane Guinney, shortstop; Everet Stringer, third base; Earl Jeffries, left field; Guy Miller, center field; and Ernest Brown, right field. How this lineup corresponds to the photograph is unknown. (Courtesy of Rod Anderson, with caption research by Bob Banks.)

Pleasant Dale School is shown here in February 1909. This school was in the southeastern portion of Monett. (Courtesy of the Monett Library collection.)

This marker stood at Pleasant Dale School, which no longer exists. It has been placed near the school's former location on what is now Highway 60, beside the Wal-Mart parking lot. (Photograph by Elaine L. Orr.)

73

Marshall Hill School was built in 1899 and opened with almost 100 pupils and one teacher, Sara Kane. Two more rooms were added in 1904. It is so named because it stood on the land initially owned by David and Eliza Marshall. (Courtesy of the Monett Library collection.)

This photograph of a Monett football team was probably taken in the 1920s. Note that the players' leather shoes are all "high-tops," reaching above their ankles. (Courtesy of the collection of Rod Anderson.)

The Walnut Grove School is pictured on March 12, 1909. It is uncertain whether it was a tradition for family members to come to the schools on the last day, or if parents came in 1909 because they knew the photographer would be there. In another photograph taken the same day, parents peered from school windows as the photographer took a picture of only the children. (Courtesy of the Monett Library collection.)

This photograph appears to be of a Central School class, given the windows. A note with the photograph says the teacher was Bess Campbell, who later married Gleason Bowen, a switchman for the Frisco. (Courtesy of the Monett Library collection.)

75

This photograph of the Talbert School was taken in 1909. Parents, siblings, and other family members have come to school for the big event of having the school picture taken. (Courtesy of the Monett Library collection.)

The coach of this MHS team from about 1920 is Walter Reynaud, who later married Helen Gillioz and worked for Gillioz Bank. (Courtesy of Helen Gillioz Reynaud.)

Central School is shown here in 1921. In the early days of photography, such large photographs were taken in segments—the actual size of this photograph is almost 18 inches. Participants would have to stand for several minutes, which is why some of them are not posed and smiling at the camera. Most Monett school pictures do not show the students in uniforms, as these girls appear to be. It is just as likely that they created their dresses for a special occasion, perhaps this photograph. Central School closed at some point, and by the 1950s served as a warehouse for Vaisey-Bristol Shoes. There was not much discussion about saving it when the city finally tore it down. Its 1890 components were simply falling apart. (Courtesy of the Monett Library collection.)

The red brick high school building on the left was constructed in 1905, and its land took up the city block at Cleveland Street between Eighth and Ninth Streets. By the early 1920s, it was too small and the adjoining building, with M. E. Gillioz as contractor, was built. This building also housed Monett Junior College. (Courtesy of the collection of Rod Anderson; photograph by Ed Shideler.)

This photograph of the current Monett High School is the result of a request to the yearbook students to take some local photographs for this book. The school has about 600 students in grades 9–12 in 2006. There are almost 2,000 students in Monett's elementary and middle schools. (Photograph by Amy Newbold.)

MHS's 1942–1943 debate team consisted of John Cline, David Whitlock, Jack Cook, Bill Humble, Robert Ege, Samuel Pittman, Peggy Dawn Ellis, Wanda Shepherd, Vera Jean Long, and Wand Lou May. Thanks in large part to teacher Priscilla Bradford, in 1941 the debate team became eligible for membership in the National Forensic League, an honor society open to schools whose teams had scored a substantial number of points in competition. (Courtesy of the *Monett Times*.)

MHS's March 1950 winners of the subdistrict debate tournament advanced to Springfield. From left to right are (first row) Carol Criswell, Noralee Phariss, Allie Belle Swindell, and Jeanine Roetto; (second row) Helen Gorsch, Virginia McCormack, Charles Erickson, Louise Fly, Bill Crane, La Trisia Kinney, Vernon Reed, Mary Elizabeth Mearis, and Carl Stockton. For many years, the high school hosted a debate tournament that drew students from throughout the region. (Courtesy of the *Monett Times*.)

The 1951 graduating class of Monett High School included George Steele, who also identified the women on the cover photograph of this book. (Courtesy of George Steele.)

A large number of the 1951 graduates attended a 1991 reunion. This photograph was taken by Fields Photography in Cassville, Missouri. When members of that family business retired not long after this picture was taken, they turned over their archives such that future profits from sales of photographs benefit the Barry County Historical Society. (Courtesy of Betty and George Steele.)

MHS's majorettes are shown in their winter uniforms in the late 1940s or 1950s. They are standing next to the high school building. (Courtesy of the collection of Rod Anderson; photograph by Ed Shideler.)

This photograph of an MHS basketball team is from probably the late 1960s, given that the players are wearing uniforms with the short pants that were popular in the 1960s and 1970s. (Courtesy of Rod Anderson.)

These young science project participants have focused on plant life. One has made a dish garden, and another's project simply says vines. (Courtesy of the Monett Library collection.)

These teachers and students hold trophies that MHS teams won during a school year probably in the 1970s. Two are for volleyball. (Courtesy of the *Monett Times*.)

This MHS girls' volleyball team placed fourth in the state competition the year this photograph was taken. (Courtesy of the *Monett Times*.)

Monett's school teams are the cubs, as this marker, donated by MHS varsity cheerleaders for the school year 1987–1988, makes clear. The marker sits on the high school grounds. (Photograph by Amy Newbold.)

The American Legion Twirling Camp ran until 1971, ending the year after longtime choreographer Homer Lee's death. This photograph was taken from a calendar issued as a fund-raiser for the camp. Girls paid $20 per week, which included housing. They stayed in school facilities such as the gymnasium. (Courtesy of Rod Anderson.)

Little League teams have existed for years, but began to really flourish in the 1960s and 1970s. This Monett team was sponsored by Patton Realty. (Courtesy of Joyce Reed.)

*Eight*

# Early Health Care Kept Expanding

Monett's first physician was Dr. M. J. Jeffries, whose family arrived when the town was Plymouth Junction. However, the person who left the greatest mark on Monett's health care system was Dr. William West, most commonly known only as Dr. West, who opened his practice above the old post office in 1899. His father was a Monett dentist, Dr. Louis West.

In January 1914, Dr. William West opened a facility that the town called a hospital. It had an operating room, an X-ray machine, a few patient beds, and a room for office visits. It cost Dr. West $5,000 to equip, but he had to close it when he went to serve in World War I. On return, he reopened his practice, and in 1928 built the larger Dr. West Hospital at the corner of Lincoln and Benton Streets, the site of the current hospital, at a cost of approximately $40,000.

As he grew older, Dr. West tried to give the hospital to the city (in 1936 and 1941), but the city did not believe it could pass a tax levy to operate it. The hospital closed in 1941, was used briefly as a U.S. Health Service isolation hospital, and closed again in 1943. With Dr. West, Dr. Frank Kerr contacted the Vincentian Sisters of Charity, who taught school in Pierce City; part of their order operated hospitals. The sisters agreed to accept the hospital, and donors in Monett came up with the $5,000 needed to remodel the facility. St. Vincent's Hospital opened its doors in April 1944.

The 1928 building was joined by a new building and eventually razed to add another addition. The Cox Hospital system purchased it in 1993.

This postcard of the Parker Drug Store is a good example of an early Monett drugstore. Note the extensive display of cigars in the glass case on the right. (Courtesy of the collection of Rod Anderson.)

Dr. William West's office and patient examining room in the 1914 building were functional and spotless. Note the fan in the right corner. In Missouri summers, the second-floor space was probably very hot. (Courtesy of Mark Henderson.)

The operating room in Dr. West's 1914 space was touted as very modern and clean. (Courtesy of Mark Henderson.)

The "new" Dr. West Hospital is shown here in about 1933. It opened in 1928, and Dr. West paid the $40,000 to construct it himself.

A crowd of 1,500 gathered to witness the dedication for the reopening of the hospital on April 2, 1944. Shown here are Sr. Mary Petra (who ran the hospital), Reverend Mother Gregory, Reverend Bishop Edwin V. O'Hara, Dr. William M. West, Dr. F. L. Kerr (who helped bring the Sisters of St. Vincent to Monett), Dr. James Steward, and Charles Mansfield. (Courtesy of the *Monett Times*.)

Monett had long outgrown Dr. West's hospital when the sisters of St. Vincent, who received the hospital as a gift in 1944, began to add onto it. This first addition left the 1928 building in place. It was not until the second new construction that the old building was demolished. (Courtesy of the *Monett Times*.)

With the new addition was a large, modern nursery for newborns. Articles of the time noted the plastic bassinets, which were easier to keep clean than their predecessors. (Courtesy of the *Monett Times*.)

The operating room in the new building is in sharp contrast to Dr. West's 1914 space. (Courtesy of the *Monett Times*.)

Hospitals are more than their medical care staffs. These two staff members kept the new building clean. (Courtesy of the *Monett Times*.)

When the new hospital wing was built, it was one of the largest buildings in Monett. This worker inspects the massive pipes that supported it. (Courtesy of the *Monett Times*.)

Hospital staff get a safety briefing from a member of the Monett Fire Department. (Courtesy of the *Monett Times*.)

After Dr. West's death, he was remembered at this unveiling of his portrait. (Courtesy of the *Monett Times*.)

Mc Shane's Rexall Drug had a sleek area to prepare prescriptions. One of the men is Kenneth McShane. (Courtesy of the collection of Rod Anderson; photograph by Ed Shideler.)

Although the fins on the car date this photograph of the hospital to about 1960, when still St. Vincent's, it looks much the same in later years, when it operates as Cox Monett Hospital. Cox purchased it in 1993. (Courtesy of the Monett Times.)

# *Nine*

# Town of Many Churches

Churches were some of the earliest Monett structures, and some of the original church organizations still exist—although generally not in the same structures. First Baptist Church organized in 1888 and first met in homes and other churches until the congregation built a frame church at Fourth and Dunn Streets, in 1890. Today they continue to worship in the brick church they built in 1918.

At least two churches predate the founding of Monett. The New Site Baptist Church organized in 1848 and is the oldest continuously operating church in Barry County. For some years it worshipped in the Walnut Grove schoolhouse. The Waldensians came to the United States after being persecuted in Europe and organized the church near then-Plymouth Junction in 1875.

The Presbyterians organized their church a little later than the Baptists, in 1888, and their building at Fifth and Cole Streets was completed in 1893. When the original church was remodeled in 1913, the congregation obtained a pipe organ from the Carnegie Foundation. They worshipped in the original building until a new sanctuary was dedicated in 1975. St. Lawrence Catholic Parish still worships in the large brick structure the congregants built in 1909, but the interior was destroyed by fire (and rebuilt) in the 1950s. St. Stephen's Episcopal Church is in the same building that first opened its doors in 1900.

There are many Monett churches that organized later—Jehovah's Witnesses, Seventh Day Adventists, and Saint John's Trinity Lutheran Church, to name a few. Today several churches hold some services in Spanish, and there are others that use Spanish as the primary language. Monett's churches continue to grow with the community they serve.

The "new" First Baptist Church, a brick structure built in 1918, is the one in which members celebrated the First Baptist's centennial in 1988. A new sanctuary was added in 1952. (Courtesy of the collection of Rod Anderson.)

The Waldensians left Europe after being persecuted for their faith. Some members of the faith initially went to Uruguay, but left there and arrived in New York. The Frisco Railroad sold (some say donated) 40 acres of land for a church, parsonage, and cemetery in 1878 in what is now Monett. More families arrived in 1887. Eventually the group affiliated with the Presbyterian Church. The cemetery and church are in the National Register of Historic Places. (Courtesy of the Monett Library collection.)

St Stephen's Episcopal is shown here in about 1909. At that time, the church would have been considered "far north" in town. Its location, just off Cleveland Street, is very much "in town" today. (Courtesy of the Monett Library collection.)

St. Stephen's Episcopal Church looks much the same in 2006 as it did nearly 100 years ago. It has new additions in the back, and the vestibule has been rebuilt, but if it were not for these and the paved parking lot, it would be hard to tell the two photographs apart. (Photograph by Elaine L. Orr.)

The cornerstone laying for St. Lawrence Catholic Church drew a large crowd in February 1909. Note the large stack of bricks ready to be used in the construction. (Courtesy of the Monett Library collection.)

This construction site was to become St. Lawrence Catholic Church. Given the number of men in dress clothes, the workers were apparently joined either by senior managers from the B. E. Merwin Construction Company of Kansas City (who built it) or by church members. (Courtesy of the Monett Library collection.)

This is the completed St. Lawrence Catholic Church prior to the fire that destroyed its interior in the 1950s. The two front towers each have a small peaked roof with crosses on top, which were not rebuilt. (Courtesy of the collection of Rod Anderson.)

From the outside, one of the few noticeable changes in the rebuilt St. Lawrence Catholic Church is that the original rose windows have been bricked over and have a small cross on them. (Photograph by Amy Newbold.)

The First Methodist and Episcopal (M. E.) Church was on the northwest corner of Sixth and Bond Streets. The Sunday School posed for a photograph in about 1914. The woman in the white hat (between the two small trees) is Bessie Doty, who was born in 1902. She married Asa George Steele. (Courtesy of Betty Steele.)

In about 1920, Rev. C. M. Smith of the New Site Baptist Church baptizes an unidentified girl in a stock tank on the Wash Montgomery farm southwest of Monett (later the home of Rev. Oscar Higgins). Alba E. Banks is the man behind the tank on the right. (Courtesy of the Jeffries Collection.)

PRESBYTERIAN CHURCH - MONETT Mo.

The first Presbyterian Church was organized November 10, 1888, and its first building was at Fifth and Cole Streets. Among its charter members were S. A. Chappell and his wife. He was later postmaster and mayor of Monett. (Courtesy of the Monett Library collection.)

The more modern Presbyterian church sits among trees on Sycamore Street, in Lawrence County. The congregation first built a Sunday School on this site, and the sanctuary was dedicated in 1975. (Photograph by Sarah Aldridge.)

The New Site Church has its name because its early members literally wanted to commemorate its new location. Prior to building the frame church, they met in people's homes and at the Walnut Grove School. (Courtesy of the Monett Library collection.)

Today's New Site Church is near the earlier location and has expanded substantially. (Photograph by Sarah Aldridge.)

This is the cornerstone laying at the First Methodist Church. Local attorney Fielding P. Sizer Sr. donated the bricks for the new church. (Courtesy of the collection of Rod Anderson; photograph by Ed Shideler.)

Church construction continues in Monett with the new building for the First United Methodist Church. It is shown here, nearly completed, in 2006. (Photograph by Sarah Aldridge.)

This First Communion group photograph was taken about 1915–1920. Participants are probably members of St. Lawrence Catholic Church. (Courtesy of the *Monett Times*.)

Monett has a 24-hour church in the form of the chapel at Cox Monett Hospital. (Courtesy of the *Monett Times*.)

# Ten
# ENJOYING LIFE AND CELEBRATING HISTORY

A town Monett's size in the late 1800s might not have been a cultural oasis, but thanks to insurance agent and grocer Ed Wilson it had an opera house that brought many traveling shows to southwest Missouri. There were numerous musical groups, such as the Elk's Minstrels, Monett Boys Band, the Just School of Music, and the Monett Music Club, which was organized in 1905 in the Sizer home. The Ozark Festival Orchestra, founded in 1980, is now Monett's longest-operating music organization other than those within the school district.

Parades have been held for May Day, Fourth of July, and during the Christmas season—at least. Either swimming was a regular pastime or folks tended to pull out their cameras when people got in the water. There are so many more pictures than could be shown here of people wading in Kelly Creek, swimming the pool in City Park, or playing in the flood waters as Kelly Creek came onto Broadway. That was not fun for business owners, but the kids sure seemed to enjoy it.

Monett's 50th anniversary celebration in June 1937 spanned several days and featured Monett Day, Frisco Day, and Church day, among others. There were basket dinners, ball games, a parade, and the chance to blow the whistle of a locomotive in the Frisco yard. The parade had cars with former students who represented classes from 1888 to 1937. Pearl Peters outdid herself with a series of articles in the *Monett Times* that traced town history, and the paper continues to feature articles on town history. Thankfully, photographers such as Ed Shideler and Logan McKee have been there to record the memories of the good times.

These five women appear to be in a public place, adorned in hats of the 1890s and early 20th century. They may well have worked in retail in Monett, as it would have been somewhat unusual to see a group of women friends out by themselves at that time. (Courtesy of the Monett Library collection.)

Charles D. Baker was the cashier at the Monett State Bank. He is shown here with his young daughter Marguerite. (Courtesy of the Monett Library collection.)

Logan McKee's interest in flying first showed in hot-air balloons, and a crowd gathered to watch this one be inflated. A fire was built alongside the balloon to heat the air used to fill it. Behind the balloon is Robert Callaway's store, which sold furniture, carpets, and coffins. The family later operated a funeral home for many years. (Courtesy of the collection of Betty Steele; photograph by Ed Shideler.)

The inflated balloon is sitting in a hole in a lot on the east side of Third Street, between Broadway and Front Street. Lynn F. McKee was often the pilot. (Courtesy of the collection of Rod Anderson; photograph by Ed Shideler.)

Most people saw a circus parade as it went through downtown streets. A resolute group of young people would always meet the wagons outside of town and walk to the circus campsite with the performers and their animals. (Courtesy of the collection of Rod Anderson; photograph by Ed Shideler.)

The domed building is the Monett State Bank, whose president was physician A. S. Hawkins. Behind it is the Attaway Hotel, which opened March 1888 at Fifth Street and Broadway. It later became the Broadway Hotel. Although the exact date of the photograph is unclear, Dr. Hawkins did not come to Monett until 1893. (Courtesy of the Monett Library collection.)

These elephants carry advertising, the first for First National Bank, the second for Newman's Clothing. Given the paucity of elephants in southwest Missouri, the crowd probably looked at them very intently, producing good advertising revenue for the circus. (Courtesy of the Monett Library collection.)

Monett had the Elk's Minstrel Group, a popular musical group of about 30 men and older boys. This September 3, 1909, parade postcard also has the awning of Logan McKee's pharmacy; it is likely he took the photograph. In 1908, the Elks' building was on Fourth Street, on the site where the Masonic temple was later built. (Courtesy of the Monett Library collection.)

The Elks were a musical group of men. This photograph shows police chief Joe Jackson on drums, and Aloin Cox is at the far left. In the background is the Harvey House. (Courtesy of the Monett Library collection.)

Harvey House's dining room was not just for travelers. This group of young people may have been celebrating a birthday. Whatever they are doing, they appear to be having a very good time. (Courtesy of the Monett Library collection.)

These Boy Scouts are climbing a limestone "cliff" in Monett in 1913. All but three are identified. The scouts at the top, from the left, with the one in a white shirt are Charlie Waite, Tillman Temple, Ambrose Shelton, and Ted Knotter. Below them are Charles Hendershot, John T. Westbay, and Leslie Mason. The next two are unknown, but the next down the rope are Charles Copeland, Raymond Kingery, and Junior Westbay. The man in the hat with a moustache is Reverend Knotter, and the scout with the flag is Lawrence Frear. At the bottom of the rope are Carl Ketring, Dr. Russell Cole, Charles Wagner, and Fred King. (Courtesy of the *Monett Times*.)

The Fourth of July celebration in 1911 was an especially big occasion, since Logan McKee was to fly the DeChenne airplane. The poster shows there were many other activities that day. (Courtesy of the Monett Library collection.)

# ED. S. WILSON,

### Dealer in

## Groceries and Queensware,

## FLOUR, FEED, Etc.

### Manager Wilson's Opera House.

## MONETT, MO.

Ed Wilson put this advertisement in the Lawrence County Directory and Cookbook. His interests were clearly diverse, since he made his living as a grocer and promoted his opera house at the same time. (Courtesy of the Monett Library collection.)

The Wilson Opera House was the product of E. S. (Ed) Wilson's desire to bring live theater and opera to Monett. Traveling theatrical companies played there, as did local groups. School plays were held there until the newer high school was built in 1907. Perhaps most notable was that the area under the balcony was the site of Monett's first public restrooms. (Courtesy of the Monett Library collection.)

The Just School of Music is probably onstage at the Monett Opera House. Pearl Lewis was one of its organizers, although the group is said not to have lasted too long. (Courtesy of the collection of Rod Anderson.)

Carmen's Band poses in front of the YMCA. The "Y" was more than a place to sleep. There would be small band concerts in front, or high school groups would have ice-cream socials in front to raise money. (Courtesy of the collection of Mark Henderson.)

Slick Bottom was on the eastern part of town, near the railroad tracks. It always had some water, but after a hard rain it was a popular swimming hole. (Courtesy of the Monett Library collection.)

These young people are probably in Kelly Creek, but the location is not clear. What is clear is that their original intent was not to go in the water. (Courtesy of the *Monett Times*.)

Even before there was a pool in City Park, there were sun worshippers. These young men are wearing bathing clothes of the 1920s. (Courtesy of the collection of Mark Henderson.)

This is the second swimming pool built in Monett's City Park. It is an Olympic-size pool that stays busy all summer. Next to it is the park bandstand. (Courtesy of the collection of Rod Anderson.)

These young men are enjoying an afternoon of fishing, probably in Kelly Creek. Judging from their clothes, the time is 1915–1920. (Courtesy of the Monett Library collection.)

This photograph was taken about 1937 on the Alba Banks farm. Seen here from left to right, Alba Banks Jr., Gerald Carlin, and Robert Banks are on a wagon they rigged as a go-cart. Steering with a rope, the boys rode the wagon down the large hill in front of the New Site Baptist Church. (Courtesy of the Jeffries Collection.)

The soda fountain at McShane's Drug Store has some prices that would be attractive today. An ice-cream cone or Dr. Pepper was 5¢, and sundaes were 20¢. (Courtesy of the collection of Rod Anderson; photograph by Ed Shideler.)

This is the soda fountain at the Café, a popular downtown lunch place in the 1940s and 1950s. On the counter behind the women are cigars and candy, including some candies that are still sold today. (Courtesy of the *Monett Times*.)

Children line up outside the Gillioz Theater for an afternoon picture show. The theater stood on Broadway from 1931 until the 1980s, when it was torn down amid much protest. (Courtesy of the collection of Rod Anderson; photograph by Ed Shideler.)

Jessie Davis (née Johnson) was a talented pianist. As a young woman, she played the piano during silent films at Monett theaters. (Courtesy of Peggy Pinnell.)

This photograph of the front view of the Monett Depot was taken during Monett's 50th anniversary celebration in 1937. On the left is Tommy Thompson, a traveling electrician, and on the right is Claude Neeley, who was a clerk in the car foreman's office in Monett. (Courtesy of the *Monett Times*.)

During Monett's 50th anniversary, the Jeffries family celebrated with this covered wagon that also promoted Leroy Jeffries Motor Company. (Courtesy of the collection of Rod Anderson; photograph by Ed Shideler.)

The West Port Club was a popular site, especially during World War II, when there were dances in the clubhouse. (Courtesy of the collection of Rod Anderson.)

Radio host Floyd Stewart was a popular figure in Monett for decades. He later served as mayor and was in that position in 1987, during the city's centennial. He was a driving force behind the production of a book of Monett's history that was published during the centennial. (Courtesy of the collection of Rod Anderson.)

118

This Amos family reunion was held in Monett's City Park in about 1952. Oscar Amos worked for the city of Monett. The woman at the far right is Enid Owens (née Amos), and in front of her are her sons Keith and Jim. (Courtesy of Keith Owens.)

M. E. Gillioz, longtime Monett businessman and admired citizen, is joined on his 85th birthday by his wife, daughter, and grandchildren. (Courtesy of Helen Gillioz Reynaud.)

Members of the American Legion lead what is probably a Christmas parade in the 1950s. On the right is Wilson's Body Shop. (Courtesy of the collection of Rod Anderson; photograph by Ed Shideler.)

This Christmas parade of the 1950s shows the strand of reindeer across Broadway. They were lit each night. Monett's marching bands started in the elementary school grades, although the younger groups usually rode on a flatbed truck. (Photo by Ed Shideler, courtesy of the collection of Rod Anderson.)

Although commercial Christmas concepts flourished, residents say there were usually several floats that celebrated Christ's birth. (Courtesy of the collection of Rod Anderson; photograph by Ed Shideler.)

Monett's Kiwanis usually have a parade float. The club celebrated its 75th anniversary in 2000. (Courtesy of the collection of Rod Anderson; photograph by Ed Shideler.)

121

Hunting has always been a popular sport in southwest Missouri. This photograph was taken during the 1954 Barry County Fox and Wolf Hunters' get-together. Dale Medlin is third from the right, and fourth is Mr. Whipple. (Courtesy of Rod Anderson.)

Margaret Stevenson Trombold was, at age 105, Monett's oldest resident in 1987. As a child she lived in Washington, D.C., and saw President Harrison at a White House Easter Egg Roll. She moved to Monett in the mid-1950s, after her husband's death, because her daughter Margaret Horn and family lived there. (Courtesy of Mark Henderson.)

While there are many organized sports in Monett, there is ample opportunity (and space) for the hobby player. These tennis courts in Monett's City Park are rarely free on the weekend. (Photograph by Elaine L. Orr.)

The bright red old Frisco caboose in Monett's City Park is a popular venue for fun. This little boy is Darrin Reed, and the occasion is his first birthday, in 1975. (Courtesy of Joyce Reed.)

The Kiwanis playground in City Park is a popular attraction on the weekends. (Photograph by Elaine L. Orr.)

Judge William Pinnell and three of his grandchildren are at the Freistatt Picnic. It is a "must" event for local elected officials. Freistatt is a few miles north of Monett and is in the same judicial circuit as Monett. (Courtesy of Peggy Pinnell.)

For several years, Monett had an annual history event downtown. These girls are looking at a window display that local history buff Rod Anderson put together. (Courtesy of Rod Anderson.)

Members of Monett's Hobbs-Anderson Post 91 of the American Legion remember veterans each Memorial Day by placing a flag on the graves of those who served in the military. (Courtesy of the Hobbs-Anderson Post 91 of the American Legion.)

This is the cover of the book that celebrated Monett's centennial. It has information on a wide range of events, and detailed family histories for many of Monett's early settlers. Some segments of the book draw on Nellie Mills's *Early History of Old Barry County*. Mayor Floyd Stewart oversaw its preparation. His wife, Dee, made some history herself by starting Monett's kindergarten program. (Courtesy of the collection of Mark Henderson.)

The Monett Kiwanis Club had Springfield, Missouri, artist Charles C. Summey paint this rendition of the Monett Depot and Harvey House and is selling prints as a fund-raiser. The color prints call to mind Monett's time as an active hub for passenger travel. (Courtesy of Rod Anderson.)

# BIBLIOGRAPHY

*Goodspeed's History of Barry County*, Goodspeed Publishing Company, 1888. Reprint, Cassville, MO: Litho Printers, 1995.

http://freepages.history.rootsweb.com/~cappscreek/index.html

http://www.rootsweb.com/~mobarry/Monett/index.htm

http://www.rootsweb.com/~mobarry/Monett/jeffriesphotos.htm

http://www.rootsweb.com/~mobarry/society.html

Interstate Historical Society. *Ozark Region, Its History and Its People, Vol. I.* Springfield, MO: 1917.

Isbell, Jane. *The Pride and Progress of St. Vincent's Hospital.* 1987.

Mills, Nellie. *Historic Spots in Old Barry County.* Monett, MO: 1952.

"Monett," *Barry County Up-to-Date.* 1922.

Monett Centennial Committee. *One Hundred Years of Memories.* 1987.

Monett Star Print, *Monett, Missouri: Its Industrial, Commercial and Social Interests, Growth, and Prosperity.* 1910.

Staff of the Monett Times. *Celebrating a Century of the Monett Times: a Family Scrapbook.* 2000.

## Across America, People are Discovering Something Wonderful. *Their Heritage.*

Arcadia Publishing is the leading local history publisher in the United States. With more than 3,000 titles in print and hundreds of new titles released every year, Arcadia has extensive specialized experience chronicling the history of communities and celebrating America's hidden stories, bringing to life the people, places, and events from the past. To discover the history of other communities across the nation, please visit:

## www.arcadiapublishing.com

Customized search tools allow you to find regional history books about the town where you grew up, the cities where your friends and family live, the town where your parents met, or even that retirement spot you've been dreaming about.